Spirit of
Powwow

*Enjoy.
Kay.*

Kay Johnston & Gloria Nahanee
Illustrations by Susanne Lansonius

ISBN 0-88839-520-5

Copyright © 2003 Kay Johnston & Gloria Nahanee & Susanne Lansonius

Cataloging in Publication Data

Johnston, Kay, 1941–

 Spirit of powwow / Kay Johnston & Gloria Nahanee.

Includes bibliographical references.
 ISBN 0-88839-520-5

 1. Powwows–North America. 2. Indian dance–North America. I. Nahanee, Gloria, 1948- II. Title.

E98.P86J63 2003 793.3'1'08997 C2003-910780-9

All rights reserved. No part of this publication may be reproduced, stored in a retrieval system or transmitted, in any form or by any means, electronic, mechanical, photocopying, recording, or otherwise, without the prior written permission of Hancock House Publishers.

Printed in Singapore – AR BOOKBUILDERS

Editing: Nancy Miller
Design and Illustrations: Susanne Lansonius
Production and cover design: Theodora Kobald
Cover photographs: Kay Johnston
Photographs on page 40 and 77 used with permission
of Clyde Hubbard and the Gathering of Nations Powwow.
All other photographs by Kay Johnston unless otherwise noted.

We acknowledge the financial support of the Government of Canada through the Book Publishing Industry Development Program (BPIDP) for our publishing activities.

Published simultaneously in Canada and the United States by

HANCOCK HOUSE PUBLISHERS LTD.
19313 Zero Avenue, Surrey, B.C. V3S 9R9

HANCOCK HOUSE PUBLISHERS
1431 Harrison Avenue, Blaine, WA 98230-5005

(604) 538-1114 Fax (604) 538-2262
(800) 938-1114 Fax (800) 983-2262
Web Site: www.hancockhouse.com *email:* sales@hancockhouse.com

Contents

Foreword . 5

Preface . 6

Introduction . 7

Chapter 1: A New Beginning for an Old Tradition . 9

Chapter 2: It's Powwow Time . 15

Chapter 3: Getting Ready is a Whole Lot of Working Together! 19

Chapter 4: The Grand Entry—Let the Powwow Begin . 25

Chapter 5: Men's Traditional Dance . 31

Chapter 6: Women's Traditional Dance . 41

Chapter 7: The Fancy Dancer—Sometimes called Dancer of the Rainbow 49

Chapter 8: Fancy Shawl or Butterfly Dance . 57

Chapter 9: Grass Dance (Northern Style) . 69

Chapter 10: Jingle Dancers . 77

Chapter 11: The Hoop Dance . 85

Chapter 12: The All-Around Competition . 89

Chapter 13: Social Dancing and Some New Dances . 91

Chapter 14: Special Ceremonies and Events . 97

Chapter 15: The Drum and Singers . 103

Chapter 16: Master of Ceremonies, Arena Director & Whip Man—Three Movers & Shakers . . 113

Chapter 17: Positions of Great Honor: Head Dancers and Royalty 119

Chapter 18: Judging Is Not an Easy Task . 125

Chapter 19: The Judging is Over—Now What? . 129

Chapter 20: Go My Son . 133

Chapter 21: It Begins Here . 135

Appendix . 139

Bibliography . 143

Acknowledgments

I wish to thank some very special people for their support as I struggled with this project.

Thank you to the voice at Tatla in the Chilcotin and to the Haida Gwaii eagle for floating his feather to my feet. Gloria for sharing her wisdom, her family and her spirit. Thank you to all of you who gave of your time so freely and generously sharing your experience and wisdom by agreeing to interviews and the use of your photos in this book.

My friends Shelly, Pat, Karen, Jan and Tricia who listened patiently to my moaning and groaning as I tried to find the special person to work with and as I procrastinated. They celebrated with me when I found Gloria, well actually it would be more accurate to say they heaved a sigh of relief and muttered, under their breath, "Oh thank God!"

Crawford Kilian for all his encouragement and help in his course at Capilano College and for his willingness to review my proposal and give concrete suggestions.

Phil Crawford, teacher at Thomas Haney Secondary, for scanning and printing digital photos and for working his magic on the very old and scruffy print of the 1940s powwow.

Ros Johnston, my sister-in-law, who came from England for a holiday and donated hours of sunny days to transcribe taped interviews directly onto disk at the speed of light.

Lor, for traveling with me all over the place from powwow to powwow; for transcribing by hand hours, probably more like days, of taped interviews for me; for proofreading and being patient when I grumped around because my mind was stuck! Finally, and most importantly, for being understanding as I worked on weekends and evenings. Your love and support have kept me going.

—Kay

I would like to thank my grandparents, the late Moses and Sarah Antone, my mom, Mazie Baker, and my late sister, Brenda Antone for all their teachings as I traveled on my life's path. They also passed on to me their beliefs in working hard and trying to help others. Wally Awasis, from The Arrows to Freedom Drum, encouraged me to revive the Squamish Nation Powwow. His support and advice were precious to me. Ray Thunderchild's dedication to the Powwow Trail, and his support and advice have helped me through the difficult and the happy times as we worked to bring back the powwow to my Squamish Nation.

I am still learning; I know I have a long way to go along the spiritual path. The Elders, my family and friends have much to teach me and I look forward to learning and growing with their wisdom. My family has stood by my side, worked with me and been so patient as we learned together how to plan and organize such a large event. Thanks to my sister, Tammie Baker, my brother, Roy Baker, my sister-in-law, Jan Baker, my brothers-in-law, Jerry Nahanee and Lane Johnston. Thank you to the Good Buffalo family, Sylvia, Brandy and Stevie for sharing all their teachings and for giving me their love and support. A special thank you to all those wonderful volunteers who worked so long and so hard to make our powwow a happy and successful one for everyone—participants and spectators. To my children Mark, Keith, Kanani and Riannon, for all their love and support.

Without the love and hard work of my husband Keith I would not have been able to do what was needed. He is always there, always willing to listen; he gives me strength to continue.

Huy chexw a (thank you),

—Gloria

Kay dedicates this book to her family

John, Ros, Lauren and Alex and her other family, Shell, Ann and Clint.

She also dedicates this book to the spirit of the Eagle and to her personal guardian, the Bear.

Gloria dedicates this book to her sister,

Brenda Joyce Antone,

in loving memory of her as a daughter, sister, mother and grandmother.

Remembered by her children William, Sandra and Shane Antone and her grandchildren Abbey, Myah, Tessa, Nicholas, Braydon, Dakotah, Justin and Mercedes.

Foreword

It is with the greatest respect and honor that we put pen to paper for our good friend Gloria Nahanee. We shall only offer a few comments at this point because this book speaks well for itself.

We have danced in the powwow for many years. The grass dancers, the women's fancy shawl dancers and the jingle dress dancers were not always a part of that circle. Perhaps "not always" is misleading with respect to the Grass Dance because it would be more correct to say "not returned."

Powwow gatherings have added a very special dimension to our lives. They are dynamic, full of good energy and uplifting gatherings. For too long non-natives have come and not fully understood the meaning of each aspect of the powwow.

This book will finally shed some light on an area of tremendous importance in our lives. We dance at the powwow because it's enjoyable to do so, but more importantly because to dance makes the earth go around. We follow the earth's path, imitating her orbit and thus we are a part of that movement. Because we are part of the movement of the earth our stopping would have the effect of ending the earth's path also. We are all connected after all.

Thank you Gloria and thank you Kay Johnston for your vision and your determination to follow your instructions given by the earth herself.

—Steven & Gwen Point
Sto:lo Nation

Preface

You may be asking yourself "Why is an Englishwoman writing about powwow?" Take a few moments and read my story and then you will understand why this is a labour of love and that I really had very little choice in the matter!

It was one of those breathtaking Chilcotin days – high, blue skies, and land that rolled away into forever. I pulled my truck in beside Takla Lake, unfolded my long legs and got out. I sat down on the grass and gazed out over the water, drinking in the beauty and power. It was overwhelming! I could almost touch the silence!

I allowed myself to become one with the earth and the sky. I was so full that tears rolled down my cheeks. A "voice', or a 'knowing" floated into my mind. So clear. So strong. I heard words, but there were no words. This message formed behind my eyes. "You must work with and for your First Nations People and Today People. You have felt the beat of the drum, the rhythm of dancing feet. The spirit of the drum and dance transcends the spoken word. The drum is the heartbeat connecting the dancing feet to Mother Earth. Use the tools you have to build a bridge of understanding." I "returned", (I can't think of any other way to describe it) to my place on the grass, somewhat stunned. "So........what was that all about?' I asked myself. I sat for a while realizing that whatever this was going to be I HAD TO DO IT. Slowly I began to understand the message as I made my connections. I have been an avid follower of the pow wow since I came to Canada in the early seventies, I loved to write and had had some success in publishing and had taken many photography courses. I now knew I had to do work around powwow using my writing and photography, but I didn't know how it was going to happen. I was on Haida Gwaii working about a year later and one afternoon I spotted this dirt road which seemed to head off to somewhere interesting. Well, I love to explore, so off I went. The road was very narrow and rough, twisting along by the edge of the ocean, taking me onto a stark, beautiful beach. I gazed out over water and pondered my "mission." I was taking lots of photos, reading everything I could find, talking to people and WAITING.....for something! I leaned against a tree and in sheer frustration called out to the air "For heaven's sake give me a clue what I'm supposed to look for next!" A single eagle feather appeared at my feet! I looked up and there he sat watching me from on high. I heard in my mind, "A dancer...there is a dancer with a vision.. You will know her when you see her and hear the beat of the drum. Together you will walk this path. " The eagle spread his wings and soared off over the trees. I picked up my feather. I had my answer, it was cryptic to say the least, but I now knew I was to find a First Nations woman, a dancer who would be willing to work with and guide a non-native along the powwow path.

Finally, I found her! I heard her name at the Squamish Nation Powwow. A drum was beating when the M.C. introduced Gloria Nahanee as the organiser of the powwow. I sat bolt upright in my seat. I KNEW this woman was whom I was meant to work with. I did some research and I discovered that Gloria was the person who had been the force behind the renewal of the Squamish Nation Powwow, was a traditional dancer, and a teacher. I have to admit to being nervous when I met her, this quiet lady exuded spirituality and power. I asked her if she would be interested in working with me on the powwow book and then held my breath. She said she would be honoured to do so; at that point my breathing resumed.

We hope our book will become a bridge between cultures. Cross this bridge with us. The Nahanee family and their friends make this book a very personal experience for the reader.

Hear and feel their heartbeat. Discover that powwow is more than a dance.

Introduction

Where did today's powwow come from? I discovered that the word powwow comes from the Algonquin word *Pau Wau* that was used to describe spiritual leaders and medicine men, the healers. English-speaking settlers could not understand Algonquin but they could pronounce some words and make assumptions as to what they meant. No doubt this was at times entertaining to the Algonquins. The settlers heard and could pronounce *Pau Wau* and knew the words were used frequently when there was dancing, singing and drumming. The assumption was made that *Pau Wau* was a time when people got together to sing and dance.

Over time the spelling changed and the Algonquin accepted the definition of the English word powwow to mean a celebration of dancing, drumming and singing. The misunderstanding was never dispelled, as neither group was aware of the mistake due to lack of knowledge of each other's language.

The original dances were organized by officers of the Warrior Societies in the 1800s. At that time only officers and privileged members were allowed to dance; women and children were not allowed into the societies and therefore were not allowed to participate.

These dances were often called Grass Dances and War Dances but different tribes had their own names for them—the Hot Dance by the Crow, the Omaha Dance by the Sioux, Dakota Dance by the Cree and Wolf Dance by the Arapaho and Shoshone. The dances traveled north in the early 1900s and became known as Omaha Dances by the northern people in recognition of the southern tribes who introduced them.

The Grass Dance is the forerunner of today's powwow. The celebrations were usually social events, a chance for families and friends to get together. In the 1920s a different type of powwow began to develop as contest dancing began to replace the old style social powwows. The contest dancing became so popular that it has now become the typical powwow, with prizes for dancing and drumming. Social powwows do still exist, usually they are held within the local community as traditional celebrations.

Native families travel hundreds of miles to take part in powwows. The link to their heritage, to ancestors, to tradition and to the power of circle make distance irrelevant. It is a time to share, to catch up with friends, to teach, to learn and to celebrate. Gloria and I know that when you go to a powwow you will see and feel the energy, the color and the beauty of the people and the regalia. We hope we have helped you to see beyond the surface and to recognize the powwow for what it really is—a powerful spiritual legacy.

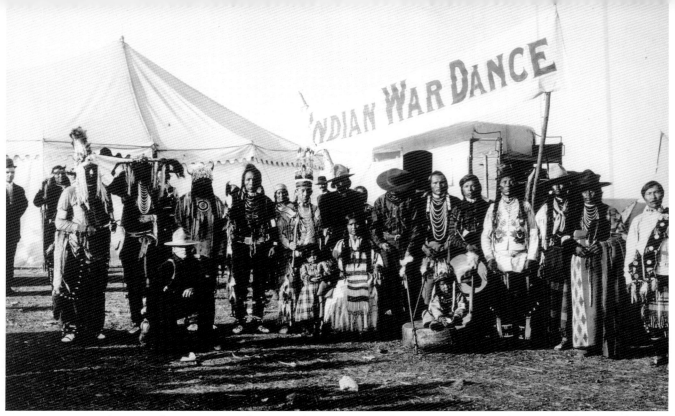

Photo: Northwest Museum of Arts & Culture/Eastern Washington State Historical Society, Spokane, Washington.

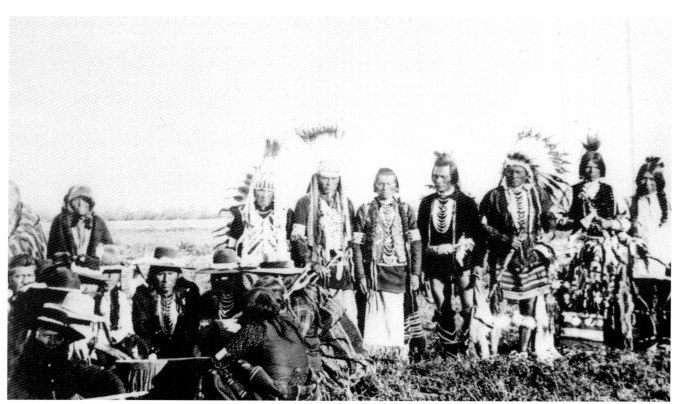

Photo: Northwest Museum of Arts & Culture/Eastern Washington State Historical Society, Spokane, Washington.

8

Chapter One

A New Beginning for an Old Tradition

The Squamish Nation held powwows in the 1940s and 1950s. Maizie Baker remembers those long-ago powwows. "Sy Baker was the one that held those powwows. The celebration would last for ten days. Humalchsun Park would be full of teepees and people would come from as far away as Saskatchewan, Alberta and Montana. We were just in the audience watching. I couldn't dance. I was mellow and calm in those days [laughing]. I had nine children. It was beautiful, all the teepees around the grounds that we were allowed to go inside and visit. The longhouse was full of arts and crafts and we could watch all the people making baskets, carving or beading."

Gloria's memories have a little different perspective from her mother's. She was only five or six years old at the time and Maizie had made her daughter's dresses with fringes on the bottom especially for the occasion. "I just remember I ran away and hid at the other end of the field. I thought I had to dance. The regalia and the noise scared me at first. I remember the stage where our ancestors, Uncle Dominic Charlie and August Jack, did the Squamish songs and dances. Probably the best one was in 1958. I remember having salmon barbecue, seeing everything that they had in arts and crafts, the powwow dancing and some of our different dance groups giving performances of Squamish songs and dances. The elders passed on and everything stopped; after 1958 the powwows disappeared for thirty years. The culture died down for a while."

In 1988 that scared little girl in the fringed dress who had run away to hide was the young woman who reinstated the Squamish

Nation powwow. Gloria prepared herself for two years by traveling to different powwows to see how they were organized. She worked at the powwows by volunteering her help in the kitchen and by selling tickets.

"Dance has led the way to our culture being revived. Ann Whannock, Wendy Harry and I formed the Squamish Nation Dancers in 1987. We had fifteen children aged sixteen and under; Ashley Harry was only four. We taught them the old songs and moves recorded in the 1940s and 1950s and preserved on reel to reel tape. We traveled together to powwows in Washington, Alberta and B.C. and we also performed in our local schools, senior centers and hospitals."

Why did she decide to take on this enormous task? Some voice deep inside her made itself heard. Gloria says, "The old spirits told me they wanted the powwow revived and that our young children would carry this on. It is something really good for our youth, for anyone of any age, to be able to dance and to be at an alcohol- and drug-free event and a gathering of all nations. It's a really good feeling."

She recalls talking about the idea of bringing back the powwow with Keith, her husband. "He listened to me then said he thought I should do it. So I went to a community meeting, where we sat around in a circle and talked about the things we would like to do for the community and especially for our youth. When it was my turn to speak, I said, 'I would really like us to have a powwow because I remember being there when I was a kid. The drumming and dancing stuck in my head I guess. I started my daughters dancing when Riannon was in grade five. I took them to the Vancouver Indian Centre and Cedar Cottage every week to learn to dance to live drums; Arrows to Freedom was one of them.'

"'One day when I was picking up my daughters from the elementary school, Wendy, Riannon's teacher, asked me what I was doing differently at home? I couldn't think of anything. I got worried right away. Like is she doing something wrong? Is she in trouble? Wendy told me that she wasn't in trouble at all, in fact she had

noticed a big change in Riannon for the better. Her self-esteem was building and she was beginning to bloom. She was starting to speak above a whisper and taking part in groups and discussions in class. I told Wendy the only thing I could think of that might make a difference was the powwows and dancing. Wendy was really interested and asked if we would dance at the school. I told her I would have to ask a drum group if they would come over to the North Shore. I asked Wally Awasis from Arrows to Freedom and he said yes that they would come. Queen Mary School had their powwow and it was a big hit with everybody for the Native kids and non-Natives. So you see it really makes a big difference in the self-esteem of our children when they dance.'

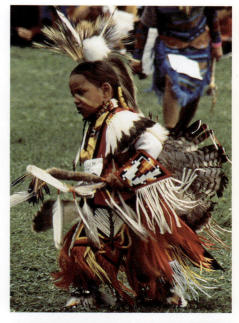

"I finished talking and waited to hear what everyone would have to say. Some of the members were hesitant and expressed concern that the powwow and its dances were not of our culture. At first I was really disappointed, I thought I would never be able to go ahead with the powwow."

Eventually Gloria's persuasive powers and her logic around the benefits for youth being able to dance and being involved in a substance-free activity overcame these concerns.

Finally it all began to fall into place. Masters of ceremony were contacted and announced the upcoming event at other powwows; flyers were sent out to dancers and drummers and to arts and crafts vendors and they came. The numbers were small in that first year; there were only about fifteen dancers. Now they number more than 200 with an audience of up to 4,000. Chief Simon Baker and his wife Emily were stalwart supporters at every powwow. During the 1999 powwow they presented Gloria and Keith with a beautifully carved female thunderbird talking stick in recognition of their hard work and support of youth. It was a wonderful way to publicly recognize these two dedicated people. Gloria, Keith, their families and friends are pleased to welcome you to their Squamish Nation Powwow and family gathering—*chet en sekwitel eslashan*. They share with you their experiences, knowledge and their heartbeat.

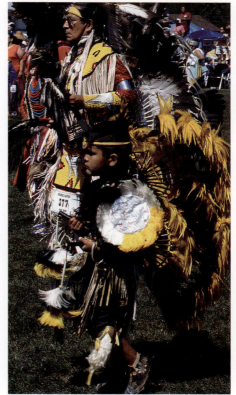

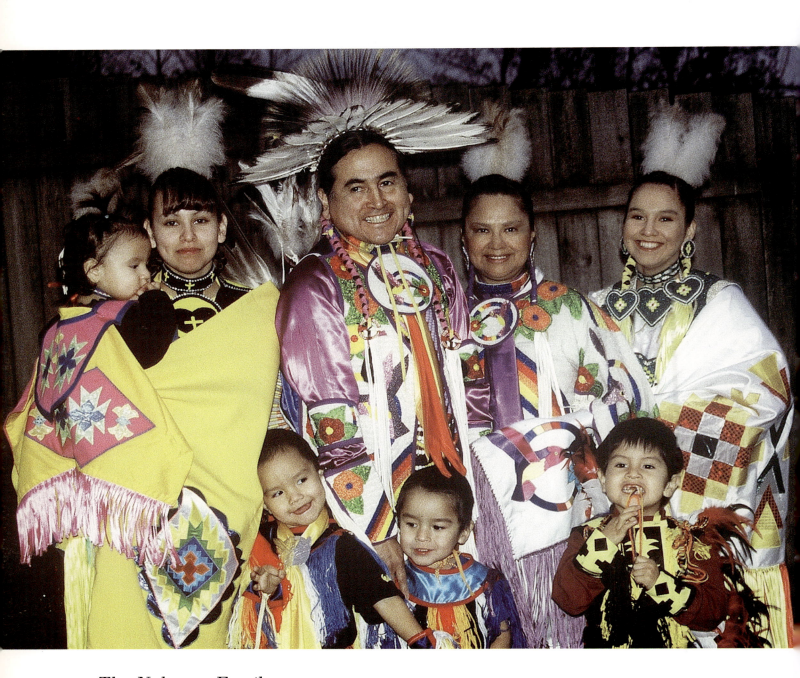

The Nahanee Family

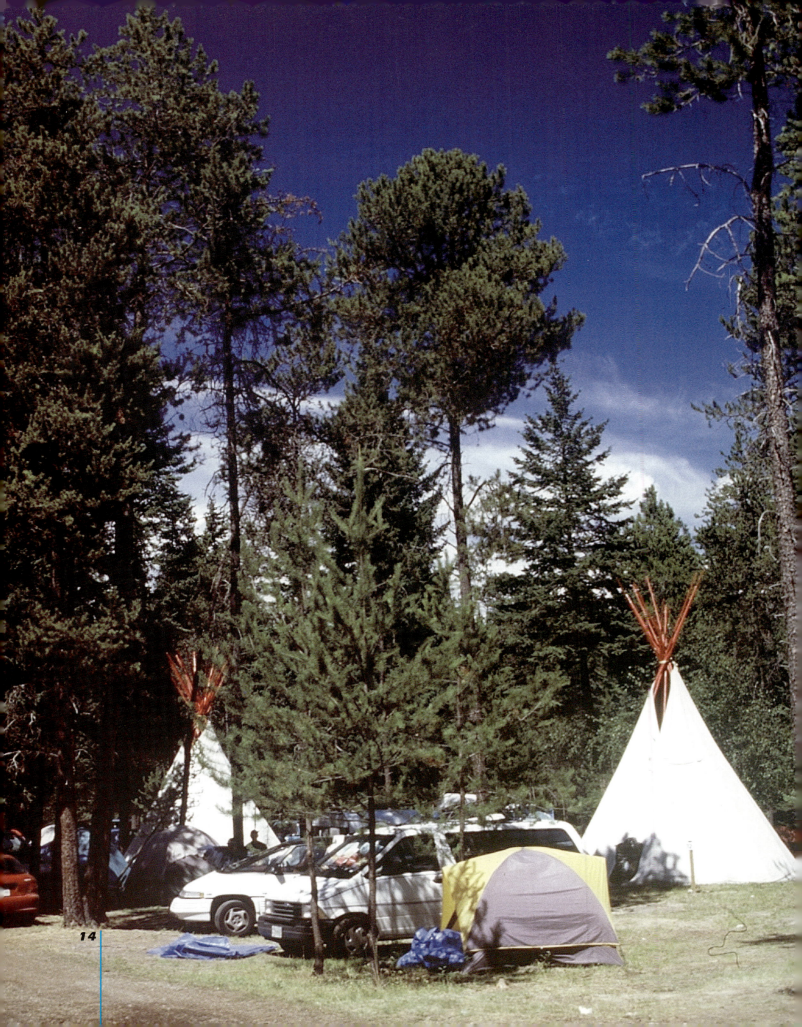

Chapter Two

It's Powwow Time

It's early Friday morning; the sun filters through the trees casting shifting bars of light across the empty arbor and the dew-covered stands. The longhouse stands silent and powerful, waiting, watching from the shadows, ready to pulse into life. An eagle soars watchfully high above.

Mother Earth is awake.

A lone figure drifts into the arbor and begins checking cables. Soon others who all have their own specific tasks join him. Sound systems are tested; craft booths slowly open their covers like sleepy eyes. The kitchen rattles and bangs into life! Laughter and the hustle bustle of a small army joyfully invade the silence. This is the host of important people, the volunteers, who make everything tick they perform tasks that are rarely noticed but hold everything together!

Rising clouds of dust, the whisper of pine needles and the crunch of pine cones signal the rolling of vans, trucks, station wagons and campers onto the grounds. License plates from British Columbia, Alberta, Saskatchewan, Manitoba, California, Washington State, New Mexico, Ontario, Texas and Minnesota line up side by side.

Campsites are set up magically, born of regular practice. Smiles, laughter, twinkling eyes, yawns, hugs and handshakes all happen at once. Old friends welcome each other and begin the age-old custom of catching up on the news and gossip. Kids play, laugh, tumble, cry and generally "help." Treasured regalia is unpacked. Precious feathers are checked; bustles are respectfully hung on doors or trees; faces are painted and hair is braided and beaded.

Time is taken to quietly offer prayers and thanks to the Great Creator. The sound of the Honor Drum fills the air and the Grass Dancers are called to prepare the ground. The beat of their feet becomes one with the beat of the drum. It's powwow time.

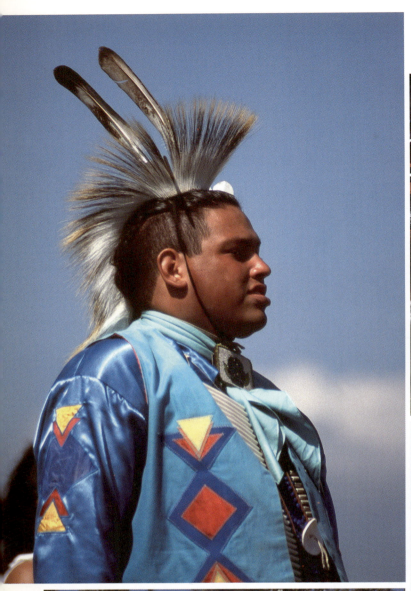
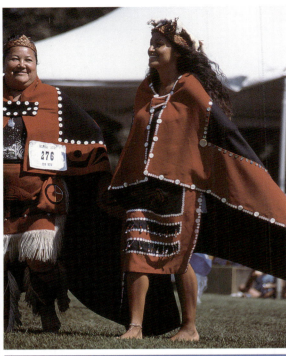
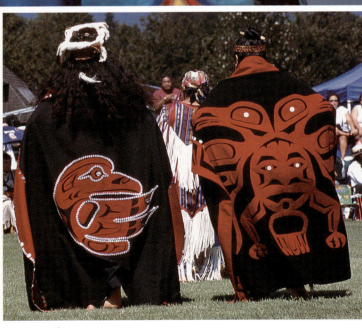
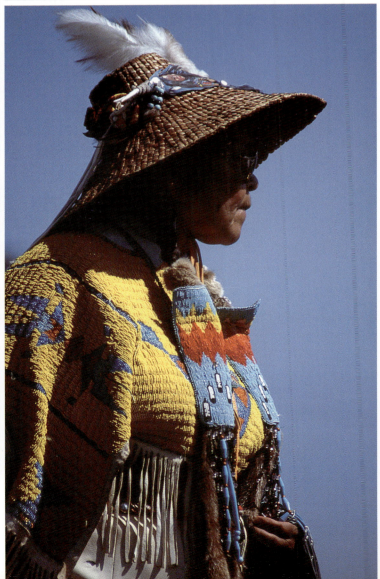

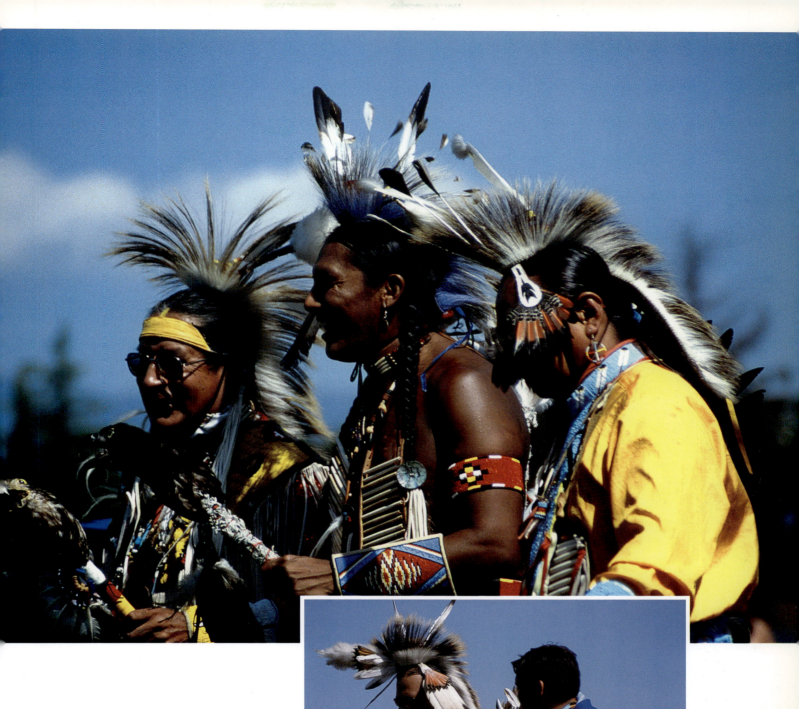

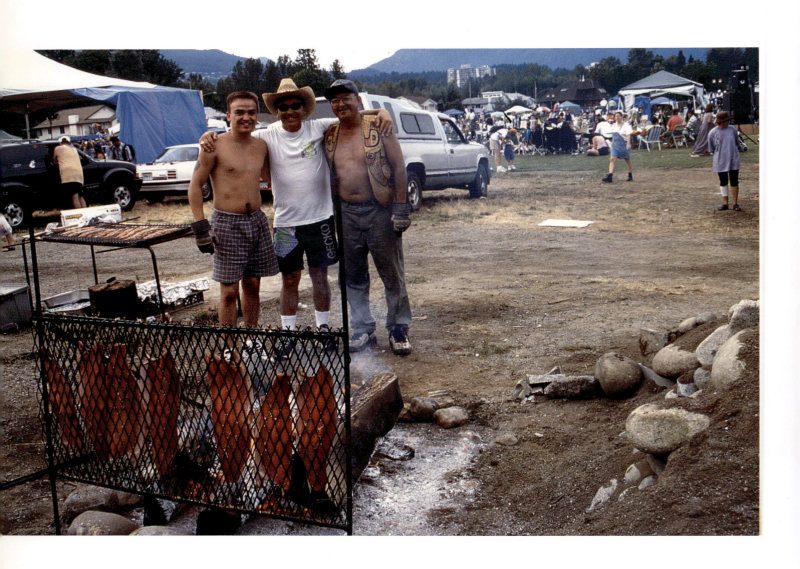

Chapter Three

Getting Ready is a Whole Lot of Working Together!

Powwow time starts long before the dancing. The Squamish Nation Powwow is held the long weekend in August, but the preparation begins long before then. The powwow circuit begins in March and the Nahanee family and their friends who travel to the powwows begin getting the word out. Flyers are given to dancers and drummers wherever they go; the masters of ceremony are asked to make announcements throughout the powwows. Word spreads really fast on the powwow trail—much faster than placing an ad in the paper or on the internet!

Gloria and Keith go to powwows to dance but also to listen to drum groups to find the Host Drum for their powwow, to hear different masters of ceremony and observe arena directors and whipmen. Candidates are considered very carefully before invitations are given. These three people are the keys to a smooth-running powwow. They have to work well with each other, the planning committee, the dancers, drummers and spectators. What a task! A good sense of humor and incredible patience are essential.

The planning committee is made up of family and friends, all of whom have their own tasks to do. Gloria knows that the work will be done, even though they all go crazy trying to do half a dozen jobs each. The committee relies on a small army of volunteers, all of whom are approached and asked personally to help. That personal touch is obvious throughout the whole powwow and is the main ingredient of its success. The list of tasks is surprising! Informing the media, printing programs and finding sponsors so that there is prize money for drums and dancers are not easy jobs, but they are fairly

typical for such events—it's the other tasks that are not visible to the spectators that are mind boggling! These are the "small" items that make the days of dancing and drumming comfortable for spectators and competitors.

Contemplate dust! Hot days and dust seem to go together in parking lots and grassy areas. Usually, but not at the Squamish Nation Powwow! About two weeks before the powwow the maintenance crew from the band spreads calcium chloride to keep the dust down. The area around the longhouse is gravel and the dust would be a nightmare. Dust gets into the regalia and can damage the delicate beadwork and the precious feathers. It can also get into the eyes of the dancers and onto the sacred drums, of course the spectators wouldn't be too thrilled to be sitting in clouds of dust either. This constant attention to the comfort of all is typical of the organizers; they work hard to make people feel welcome.

Security is also an important factor for the ease of mind of the competitors and the audience. Lane Johnston is in charge of security and two weeks before the powwow he begins to organize his team. They are responsible for making sure there are no problems, such as alcohol or drugs, and that the campsite for the competitors is safe throughout the three days. Keeping spectators happy can be one of their tasks too, such as assisting with lost items or helping find lost kids, or as the kids would say, "lost parents!" They work long hours, from early morning until the wee small hours of the next morning. Sleep! Ah yes, well it just has to wait awhile, a few power naps grabbed whenever possible throughout the three days somehow keeps them going!

Powwow power, the kind to run sound systems, lights and the crafts booths uses 1,500 pounds of cable and has to have a special power box that is hooked up the night before. Early Friday morning, fences are erected before your eyes. Delmar Williams works the sound systems, Keith and Jerry set up lights. Awnings are raised over the stage and booths and the grass is cut in the campground. It is a veritable hive of activity (one gets out of breath just writing about it!)

Gloria tells of going to one of the big warehouse stores on a shop-

ping spree! "$7,000 of pop, hamburgers, salsa, kidney beans, flour, hot dogs, fries, vegetables, and buns. Eyes light up when they see me come in! Unfortunately it all has to be unloaded too. The fridges in the longhouse are packed to overflowing on the Thursday evening ready for action the next morning." Powwow time means the dancing is beginning. It also means the kitchens are open. Time for bannock!

Bannock is the wonderful bread without which no powwow is complete! The Amazing Maizie Baker, Gloria's mom, makes the BEST bannock! Imagine her surrounded by six frying pans going full speed, helped by her daughter, Brenda and her boyfriend Tim. Brenda has now passed away but Tim still helps by flattening the dough and Margaret Canute now turns the bread as it is frying. Maizie has big pans full of flour and baking powder and she is mixing in the water. There is flour on her hair, all over herself, on the floor, the cupboards—EVERYWHERE. There is an air of fun and concentration as the assembly line zips along and boxes fill up with hot bannock. She goes through twenty big bags of flour, which means she has fried approximately 4,000 bannock throughout the weekend. She is small, about 4'11", but she stands ten feet tall when she makes her famous bannock.

Gloria says, "My mom uses electric frying pans. It's more work but they make the best bannock. The deep fryer—that's the most gross bannock ever! My mom has a good heart and it shows in her bannock. All the people love it and come back for more. My mom is fast in everything she does. My late grandmother, Sarah Antone, was like that too, a really hard worker. People watch for my mom, especially the elders, and they follow her on her way to the powwow asking, 'Can we buy right from you?' As soon as the bannock comes through the gate people come running to the concession. 'The bannock is here. The bannock is here.' The word spreads through the powwow ground like wild fire! There is one driver who has the full time job of doing bannock runs from my mom's kitchen two miles away in North Vancouver to the powwow ground." (There have been rumors of plans for bannock hijacking!)

The hard-working volunteers take happy faces and voices into the

kitchen with them. The hustle and bustle in the kitchen mixes with sounds of laughter and good-natured banter. They say that a good happy spirit in the kitchen carries over into the food, which then makes happy visitors. Certainly seems to work great. Happy smiling faces follow the first bite of the great-tasting Indian tacos, hot dogs and fries. The only complaint heard was from someone who was suffering from an over-extended stomach due to eating his third piece of bannock. He was still smiling though.

Even though 600 pounds of salmon seems like a lot, it was so good that they ran out! The family had to come to the rescue. Shawn, Gloria's brother, and Wilfred Baker, her brother-in-law, drove out into the Fraser Valley at eleven o'clock at night to get more salmon from a cousin, returning after one in the morning. Wilfred was up the next morning barbecuing at half past six. He cooks a lot of salmon at once on the racks over the fire pits fueled by alder wood, which is seasoned all year so that it is really dry. The smell of the salmon and the wood smoke makes the nose twitch and the mouth water!

The happy spirit spreads throughout the grounds. The parking attendants greet you with a smile, the ticket booth staff beam as they stamp your hand and the sellers of the 50-50 tickets can charm the last dollar out of your pocket! With all the food and heat making everyone thirsty, portable biffies are essential. Fortunately someone on the committee always remembers to order them, which definitely creates a happy spirit. Thank you!

Everything is ready.

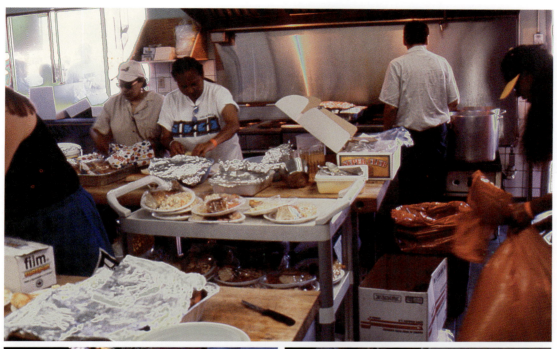

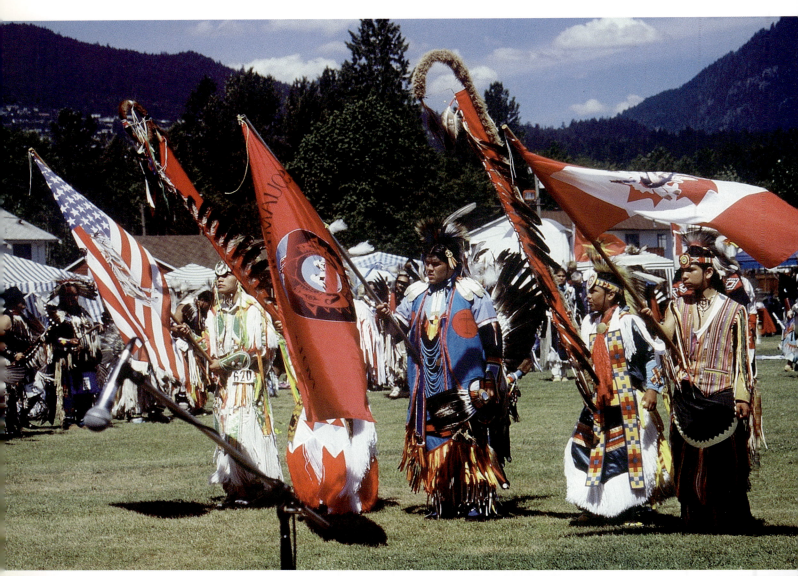
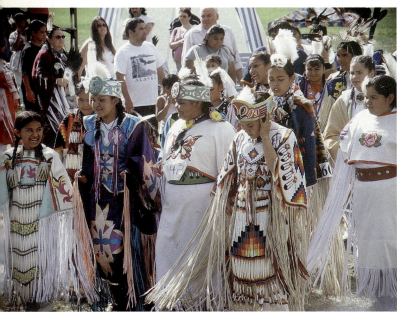
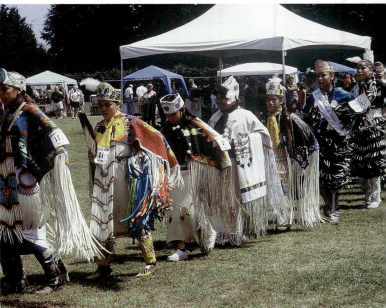

Chapter Four

The Grand Entry—Let the Powwow Begin

The honor drum begins, the beat pulsing, palpable, touching everyone here. The singers' voices rise creating an air of excitement and anticipation. Something special is about to happen. From the far side of the arbor the steady rhythm of the drum is picked up by hundreds of feet, accompanied by the rattle of hooves and the jingle of bells. The earth seems to vibrate. Spectators rise, respectfully removing hats that do not have an eagle feather attached, as the Grand Entry begins. What a sight to see—the color, the movement, the sound, the sense of pride is almost overwhelming.

The Flag Bearers enter proudly carrying the Eagle Staff, the flags of Canada and the United States, their feet lightly touching the ground, their heads held high. The Squamish Nation has dedicated their powwow to youth and young dancers are honored by being asked to be Flag Bearers. They walk tall as they lead the Grand Entry into the arbor.

Veterans who fought for their country follow them, next come the Head Man and Head Lady dancers and the Princesses who are ambassadors representing their various bands. The dancers enter the arbor behind this honored group. The Elders are greatly respected, therefore, they are the first dancers to enter the arbor. Most of the men wear the traditional regalia of buckskin, feathers and bustles; the women wear the beautiful beaded northern regalia. The Men's Traditional Dancers, the Grass Dancers and the Fancy Dancers follow close behind creating a ribbon of color. The Women's Traditional, Fancy and Jingle Dancers enter the arbor next. Their braided hair shining, fans held high, their moccasins touching the

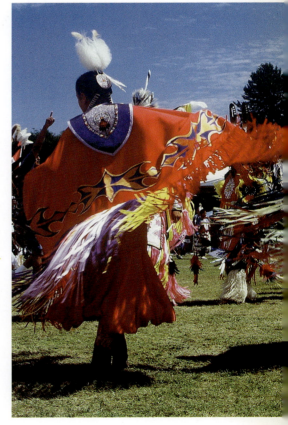

25

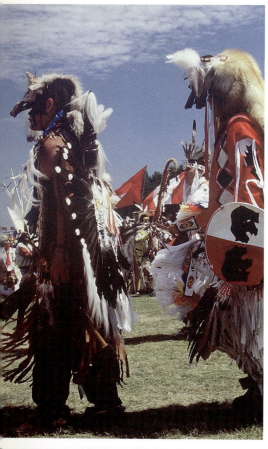

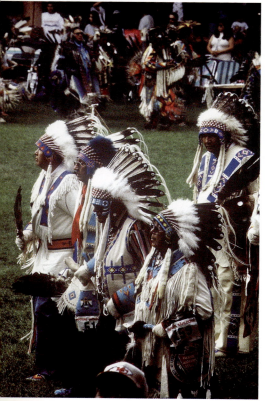

ground like feathers as the sound of the Jingle Dancers keeps time with the drum. The final groups to enter are the Teens, aged thirteen to eighteen and the Juniors aged six to twelve. These young people may be the last to enter but they have enough energy to light up the whole place. When every dancer is in the arbor the drumming and dancing stops.

Feathers, beads, fans, shawls and bustles pale beside the powerful sense of spirit reaching out from the faces and eyes of these dancers as they stand in silence and the ceremonies begin.

A respected elder delivers a welcome and prayer in his or her own language. The Great Creator is thanked for bringing everyone together and is asked for a successful powwow and for the safety of all there. Pride is expressed in seeing all the dancers, especially the youth, taking part. The dancers and drummers are told from the heart, "It is important to be proud of who you are and of the powerful culture you belong to." The invocation closes with a moment of silence, which is broken by the sound of the Honor Drum as it begins the Flag Song. The arbor remains quiet, the dancers standing respectfully as the Honor Drum moves into the Victory Song. The Flag Bearers hand them over to be posted in full view until the powwow closes for the evening. They will take them again at the closing and keep them safe and ready for the next Grand Entry, held either that evening or the next day.

After the posting of the flags the honored speaker stands to address the dancers, drums and audience. The committee invites the closing speaker because he or she has a life experience to share or because he or she is a positive role model for youth. History and the importance of ancestors and culture are part of the speech, and youth is told of the advantages of a drug- and alcohol-free life and of the freedom education can give them. A veteran tells of how he fought for his country and the effect it has on his life or a recovering alcoholic talks of his fight to save himself and his spirit. Whoever speaks has the ear of the dancers and the people in the stands because they speak from experience and with passion. The speaker is usually the one who closes the opening ceremonies and is followed by the Honor

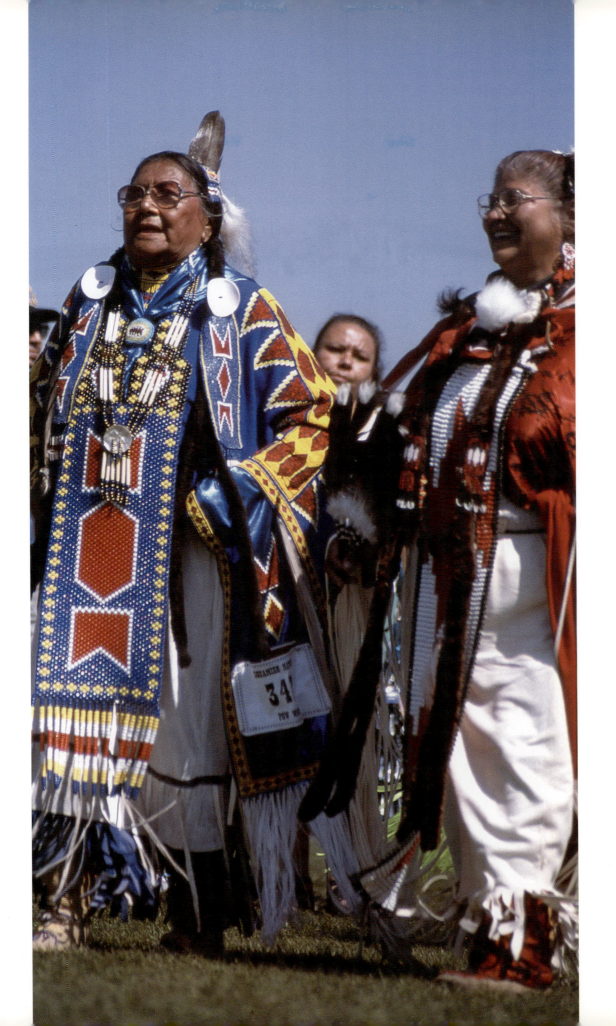

Drum singing and drumming as the dancers leave the arbor to get ready for the beginning of the competition.

Watching the Grand Entry from the stands is exciting. It is impossible not to move with the rhythm of the drum and be caught up in the energy. At the same time one wonders, "What is it like to be down there? What does it feel like to be a part of this powerful, vibrant ceremony?"

Keith Nahanee, *kwetsimet*, shares his personal thoughts and experiences with the Grand Entry. "Dancing the Grand Entry for me is one of the best parts of the powwow, whether it's an intertribal or competition powwow, because to me it represents one of the spiritual parts of the powwow. The way I was told is when they dance in the flags and the colors they're bringing in the spirits of the ones who have gone before us and they are dancing there with us, like we are taking part in something old and something sacred. It gives me a good feeling. The really special time is when they honor you and ask you to carry in an Eagle Staff, or flag, because you are right at the beginning of the Grand Entry. Most of the time it is somebody they respect or somebody when they look at them makes them feel good. It might be the Arena Director or somebody from the committee who chooses. It's just the way you make them feel when they see you. When I first started dancing, probably in my first or second year, they asked me to be a Flag Bearer; I was so honored because just being a beginner, it was something special to be asked to do that."

The excitement of the drums and the dancers, young and old, blends with the sense of pride and connection to their culture and revered ancestors. At the same time each person has their own personal spiritual experience and moments of feeling honor and respect during Grand Entry. This creates an interesting sense of togetherness and at the same time an awareness of each individual dancer for the observant person in the stands. It is a unique experience and creates the mood and the energy that clearly says, "Let the powwow begin."

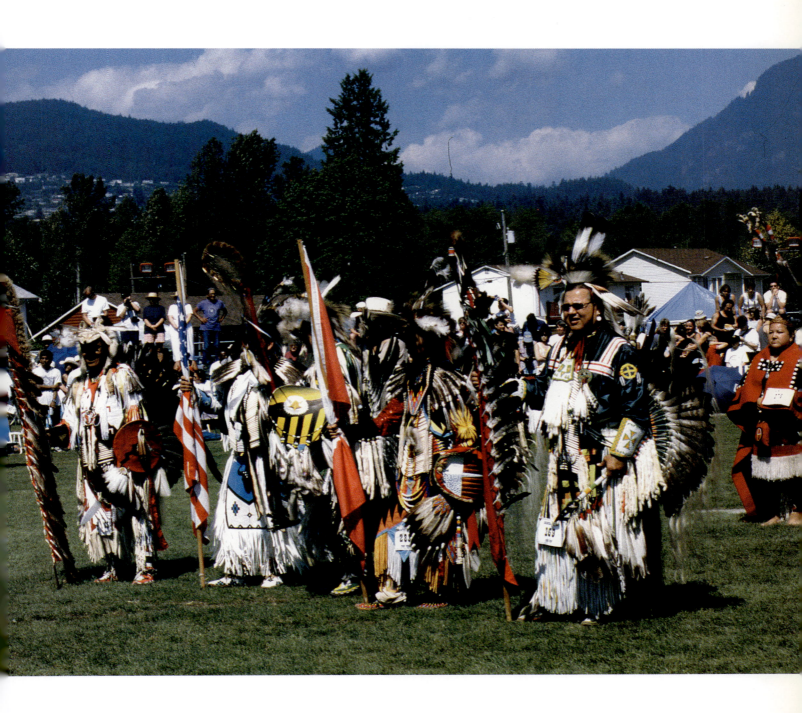

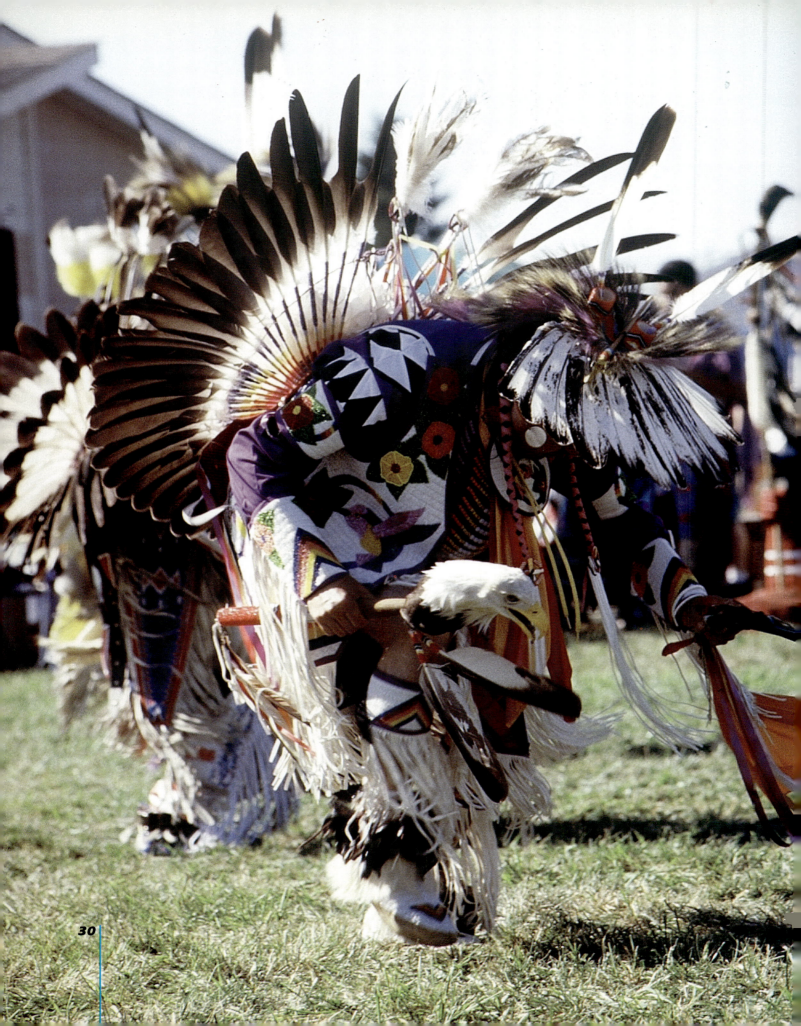

Chapter Five

Men's Traditional Dance

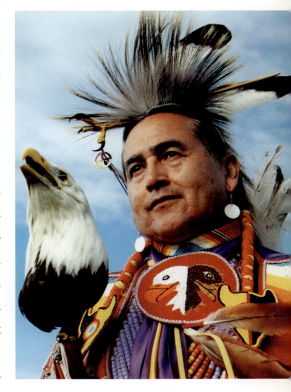

Spectators new to powwows often have some idea of what to expect in traditional dance; they have a vision in mind of the regalia and may have heard that the dance movements imitate warrior actions, hunting or animals. This is true, but we thought you would like to know a little more. Knowing some of the history behind what you see happening before your eyes somehow seems to add that extra life and energy.

The men's traditional dance style originated in the eighteenth century, emerging from the Warrior Societies. Each society had its own dances, songs and regalia and from these beginnings developed the dances and regalia we see at the powwows today. For example, the eagle bustle and the porcupine hair roach are said to come from the Omaha Society.

The Warrior Societies faded away by the end of the nineteenth century but the dancing continued to spread as people traveled from tribe to tribe sharing in feasts and social gatherings. The restrictions by the Warrior Societies regarding the participation of women and youth gradually relaxed and the dancing became more of a social event. Eventually both women and youth Traditional Dancers began to take part in the dancing. Today they play a full and important part in the powwows, bringing with them their grace and special energy.

Men's Golden Age Traditional Dancers are usually the first to perform at a powwow; this is to give them respect for their age, experiences and wisdom. The dancers, drums and spectators stand as a sign of their respect for these impressive elders. Some of them look quite fierce with their painted faces, eagle staffs and animal head-

dresses, as they become totally focused on the dance, which may be a Sneak Up or a Warrior Dance. The dancer uses the movement of his body, feet, hands and head to tell the story of the dance; he becomes the bird, such as an eagle, or animal, he is the warrior sneaking up on the enemy. The movements are so natural that you can see the story unfolding before you and quickly become involved until, suddenly, with the last beat of the drum, turn of the head and

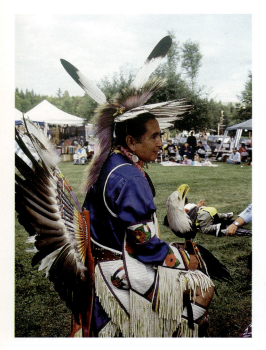
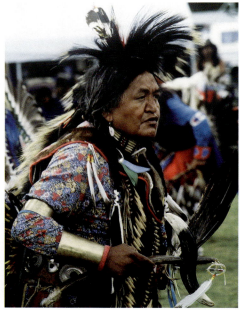
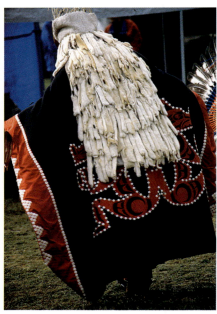

shake of the staff, the dance ends too soon. Dancers and spectators almost seem to have to shake themselves to "return" from the hunt or the battle.

Keith Nahanee, whose traditional given name is *kwetsimet*, is a Traditional Dancer. He describes his favorite dance, the Sneak Up. "To me a very special time, or a very special dance, is the Sneak Up. They say that when your dancing the Sneak Up, it's like your sneaking up or trailing your enemy or else sneaking up on prey as you're hunting. It is always the beat of the song and the way that I dance, it really makes me feel good—like it's something special. They say when you're dancing that the Spirit, that's the one that guides you when you dance, will take over you and the way you dance. And that's what makes you feel so good when you dance. You always notice that when you see pictures of people when they're dancing, a

lot of the time they're in their own world. You can see it on their face, in their expressions. That's because they say that every dance, every song was sacred a long time ago, that they were all gifts from the Creator and they are all a part of your spirituality—things that give you strength, things that guide you, make you strong. The Sneak Up, that's when it opens up me the best, makes me feel really good after I dance it. It makes me feel good for a long time."

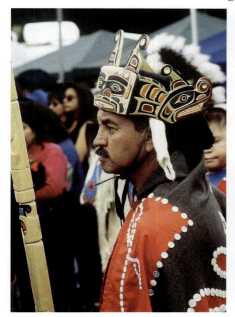 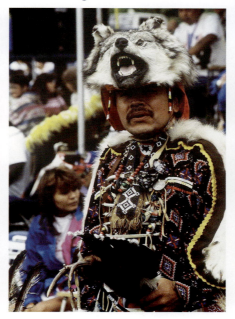 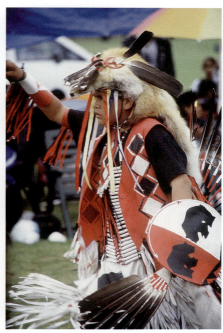

Keith's regalia seems to have quietly come together over many years, without him really being aware of what was happening. He says the Creator had a plan. "When I first started dancing and put together my first outfit, there were eagle feathers, beaded pouches, moccasins, all kinds of things that I had gathered over the years that had sat in cupboards and drawers, some for several years. I never ever knew what I was keeping them for or what I was going to do with them. Then, when I decided to dance, they all came together and I understood what it was all for.

"When I'm getting ready to dance and putting on my regalia I always think of the times when I would sweat with the good brothers. They would talk about giving thanks to the animals that have given up their lives to help us to be strong when we're dancing, to help us to be strong when we're living. I give thanks to things that give me pro-

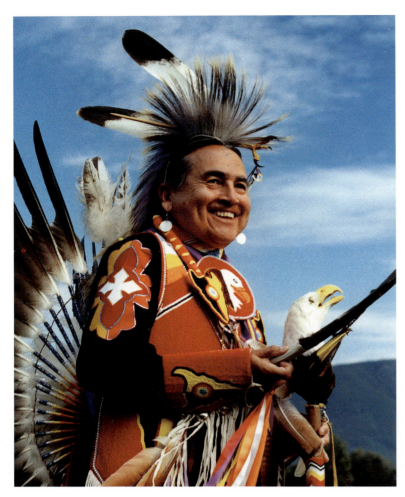

tection and strength when we're traveling, that give me strength and protection when I'm praying and when I'm dancing. I think of the deer whose hooves I wear on my ankles, they help me to keep time, help me keep that beat when I'm dancing. I think of the deer or the moose that gave us the skin that we use to make our moccasins and our regalia from and the fringe that sways when we dance. It's like a part of that deer, like the beat of its heart, helps me to keep time, helps me to be light on my feet. I think of the eagles and the hawks, the swans. The spirits of those birds live on in the feathers that we wear. They carry us and help us to be light and our spirits to be light. They say that because the eagle flies the highest, it carries our thoughts and our prayers to the Creator. They say that the Creator would send back his visions for us of the things that we need to carry us in this life. He would send the dreams, the visions that give us our bead work and show us how to make our regalia, show us what we should wear, the colors and designs that are all a part of us.

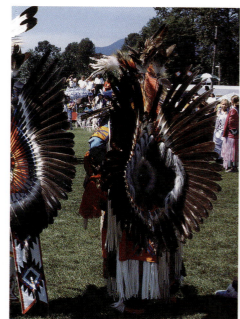
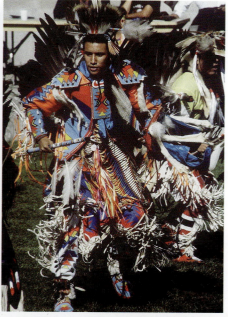
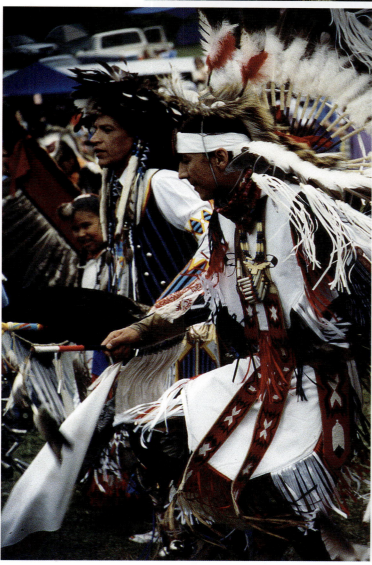
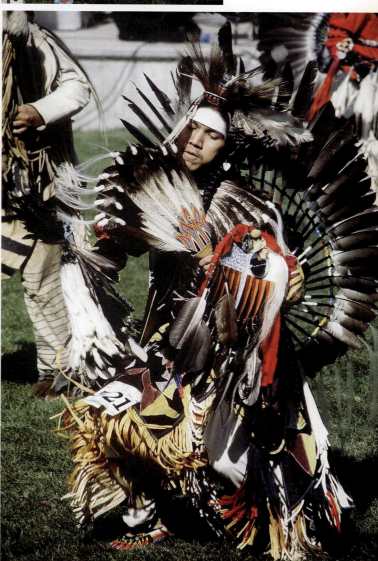

"Men Traditional Dancers wear what's called a roach, a porcupine roach. It's made from the guard hairs of a porcupine and it's strung so that it will sit on top of our heads. In the olden days it was just held on by a top braid on the top of your head and it passed through the middle of the roach and you put a stick through the braid and that's what kept it on. Everything else is made out of buckskin and now it's often fully beaded. The designs are many and individual. There are more contemporary styles of vests, cuffs, arm and leg bands today. Some people wear full leggings of an older style that go right from the hip down to the ankle. We wear an apron, which in the olden days probably used to be a breechcloth, and a breastplate made from a moose bone. But some people wear what's called a loop necklace that goes right down to your waist. We wear a single bustle on our backs

made out of eagle feathers and carry a staff or a war club in one hand. In the other hand we carry an eagle fan. A lot of people today wear bells but most of the Traditional Dancers wear either deer hooves or elk hooves on their ankles."

The sounds of the hooves rattling, the bells and the pounding of their feet on the earth in absolute time with the drum as Keith and his good brothers dance is a whole body experience. It is almost impossible not to move with them. Even people who swear they do not have a rhythmical bone in their body twitch somewhere.

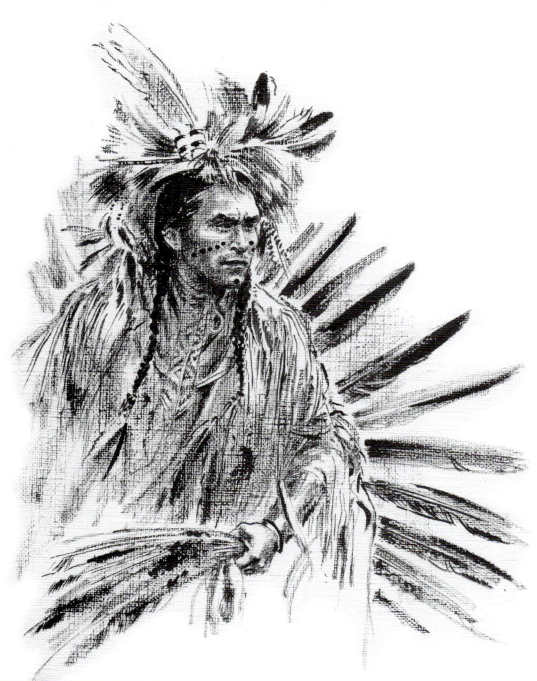
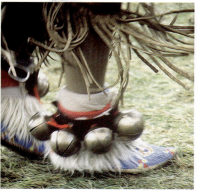 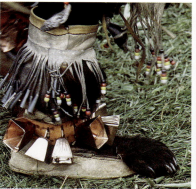 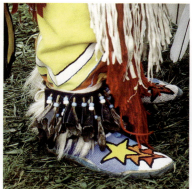 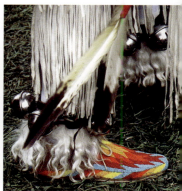

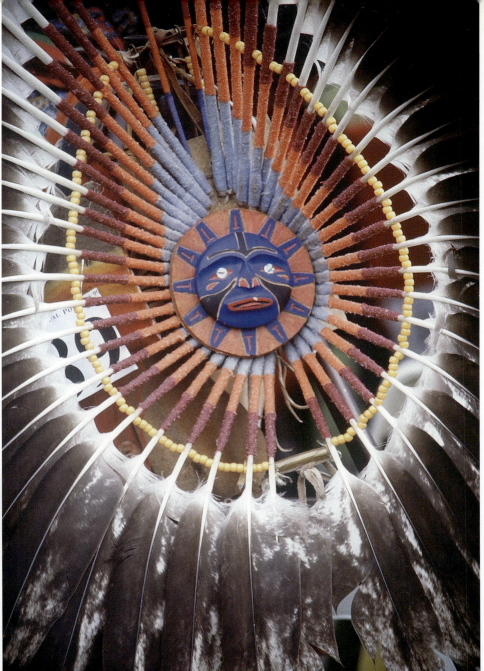
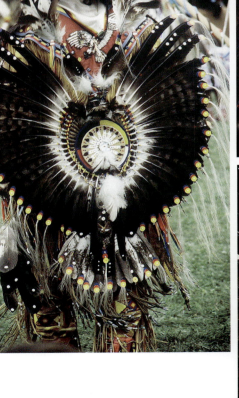
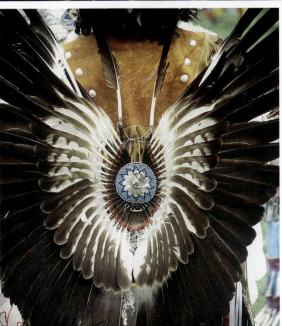

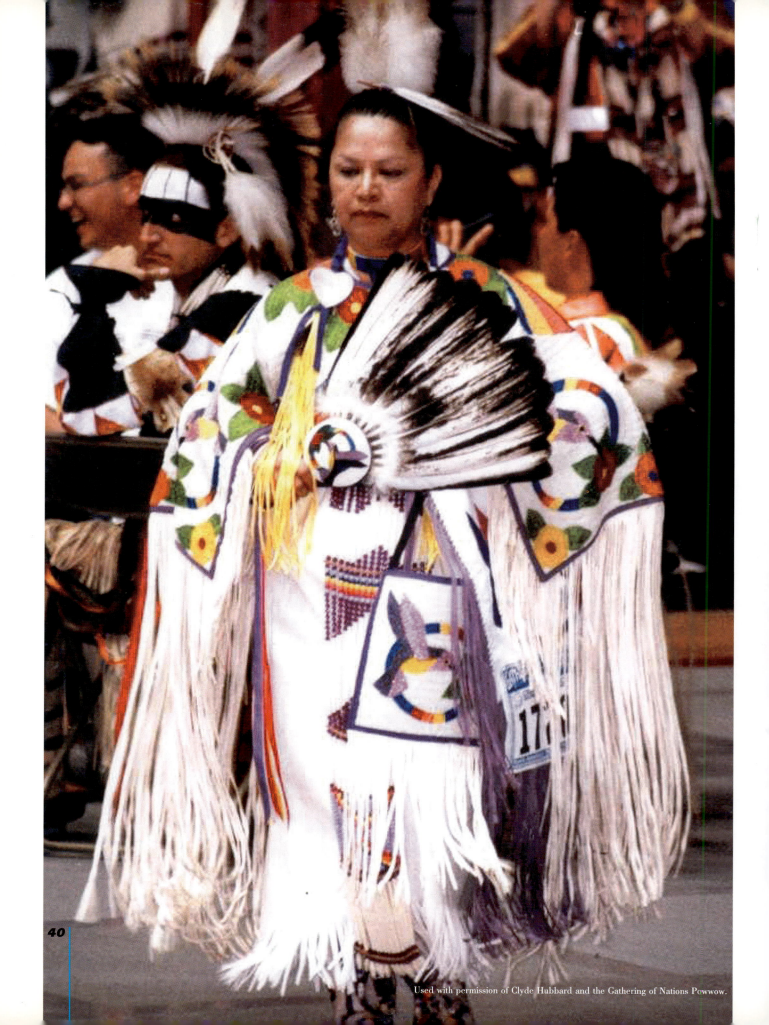

Used with permission of Clyde Hubbard and the Gathering of Nations Powwow.

Chapter Six

Women's Traditional Dance

The Women's Traditional event always follows the Men's. The energy is completely different in this dance. The women move gracefully with a quiet pride and elegance and always appear so calm and grounded as they stay in contact with Mother Earth, while raising their fans to the Creator.

The Golden Age women are the first to dance in the women's categories. Spectators will usually stand as a sign of respect for them. They always seem to carry with them something special, whether it's a sense of timelessness, age-old wisdom or sometimes a glint of mischief twinkling out from under the shade of their fans. I recall Ray Thunderchild, who was the Arena Director at one of the local powwows, announcing that the Golden Age Women were excused from dancing because the ground was so wet. Well, that was a mistake. Out from the dancers' seating marched this group of Golden Age Women to tell him that there was no way they wished to be excused, thank you, they were going to dance. They did with their usual grace, but with a twinkle in their eyes too.

Gloria Nahanee, *tenálh* is her traditional given name, is a Traditional Dancer. However, her first dance steps were from cultures other than her own. She attended St. Paul's Indian Day School as a child and was taught Scottish, Irish, Ukrainian, Dutch, Spanish and square dancing by the nuns, who also made the dance costumes. She first became interested in her own culture's dancing when she and Keith were visiting Kamloops and, by chance, they heard about the powwow and went to watch. It wasn't until after her daughter, Kanani was about six years old that Gloria herself began to

41

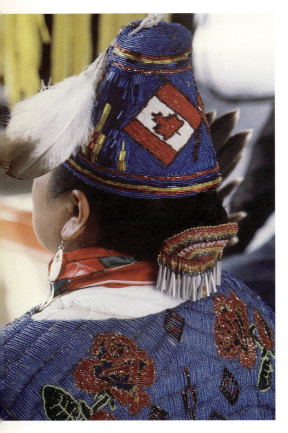

try dancing. She tried Fancy and Jingle a few times. Finally she decided she preferred Traditional. Gloria speaks of her experiences with quiet modesty and humor, always connecting to her spiritual beliefs, family and the elders who taught her so much.

"It took me a while to be able to learn to dance softer, slower, more graceful. I was very shy at first about doing Women's Traditional. I had no regalia; I just had a shawl. I watched the other ladies dance. Of course every dancer has her own way of lifting a fan or moving her head. It took me a couple of years to be able to coordinate all the moves, to use a fan in one hand and carry a shawl in the other. I used to practice at home in the livingroom when the girls were at school and Keith was at work. I would keep trying and trying, sometimes I felt like I was going to fall flat on my face. Taking such small steps needs balance, really good balance, and sometimes one foot would go over to the side. Women Traditional Dancers must always have one foot on Mother Earth with every drumbeat. You are taking tiny steps and don't really lift a foot off the ground, you are sliding your foot forward then back, forward and back. It's not easy. You are using a lot of leg muscles, your foot, then your calf and then your thigh. You really have to know the floor or surface you are going to dance on. Some areas are grass or dirt; some have lots of bumps.

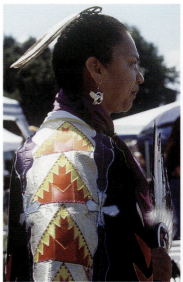
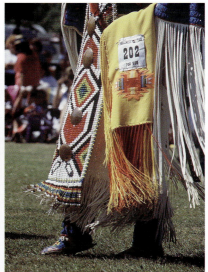
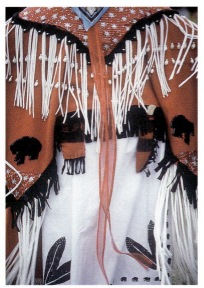

The intertribals give you a chance to get to look for holes, rocks or bumps. You could fall and break an ankle, especially in the fast dances if you didn't check the ground first.

"There are different kinds of dances in Women's Northern Traditional, just as in the Men's. The Straight Traditional is done to a regular beat song with a one-step, two-step pattern. The Round Dance is more difficult. You are dancing sideways, leading with your left foot and it's hard because you have to keep in time with the drum; sometimes the songs have a really fast beat and you have to keep up. The Stationary Round Dance is the old style of Women's Traditional; you dance around on one spot and you can't lift your feet from the floor. The Northern Traditional Dancers raise their fans in the air to the Creator on the hard, or down, beats of a song. The Southern Traditional Dancers lower their heads toward Mother Earth.

"I had to learn the patterns of the songs so that I knew when to raise my fan or when the song was going to finish. The drum has four push-ups, also called starts or verses, for contest dances; each push-up has three parts and the hard down beat comes on the third part of each push up. The dancers in all categories have to know the songs so that they know when the downbeats come and when the song

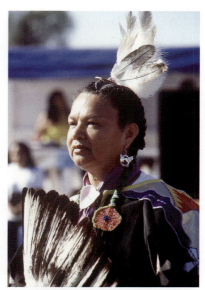

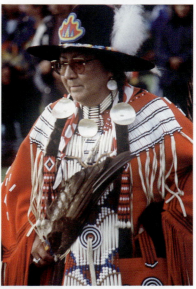

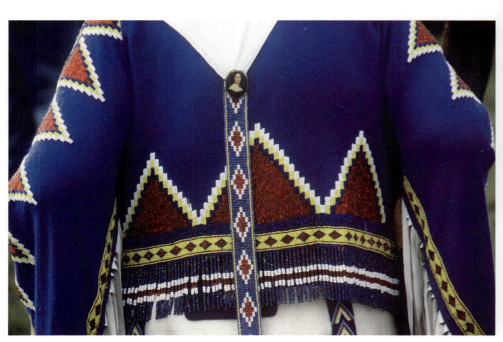

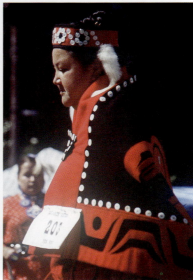

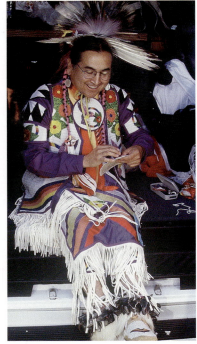

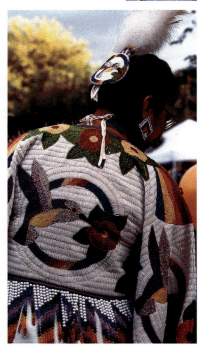

stops. This explains why you see so many dancers standing around drum groups with tape recorders and buying prerecorded tapes."

The regalia for Women's Traditional is like the Men's Traditional—personal and unique. Keith made Gloria's regalia but the central design came to Gloria in a special way.

"I came out of my front door one day and I was waiting for someone to pick me up. All of a sudden, 'Whoosh,' this little thing went whizzing by me and landed in the little tree in the corner of our yard. I was standing there looking up and wondering if it was a hummingbird and then it came flying down to a little flower bush right beside our porch and was buzzing around the flowers. I was just amazed. He was so close to me and I thought 'Wow!' Maybe a couple of months later my sister-in-law, Jan Baker and me went for a spiritual bath way up in the river. We were walking out of the park at daybreak when I saw this bird fly close to the ground; it was a hummingbird. I got all excited it was so early in the morning, and our elders say that the hummingbird brings you good luck.

"I had been trying to think of a design for a year. Keith had already bought my beads in Alberta the year before but I hadn't been able to think of a design. I knew whatever it was it would have to last because it was going to be a lot of work for Keith. After two visits by a hummingbird I knew what my design was to be. I told Keith, 'It's a hummingbird.' He drew it out for me and, of course, it was just beautiful and so he started on my regalia. First he started my barrette and my leggings and my moccasins and he gave them to me for Christmas. It was such a surprise. He told me, 'You'll have to wait for the cape.' It took him a whole year to bead my cape; he would sit there all weekend from early morning till late at night just doing the beadwork. He carved a hummingbird on the handle of my eagle feather fan and painted it so it matched my beadwork. He is so gifted! He weaves beautiful blankets and is a wonderful carver! Oh! You should see his work! He came up with the design for my shawl. It is a hummingbird with the circle and the flower. Our dear friend Clarissa Young, from the Lummi Nation, made the breast plate for me; the colors are purple and white to match my design. Keith

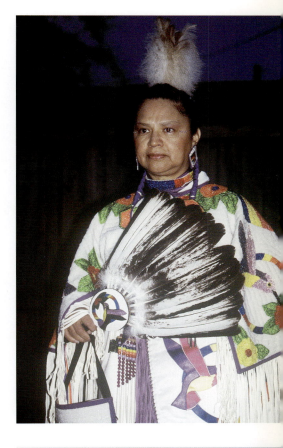
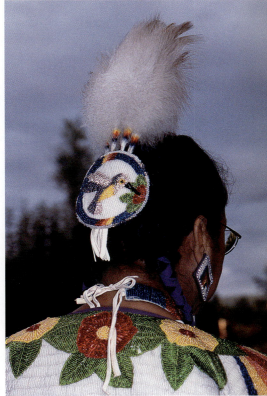

designed my hummingbird earrings and had them made in silver. Now I just need the wrist cuffs.

"The dance regalia is originally from the Plains. I've always felt that in a different life I must have been from the Plains. I've always really loved the teepee, when I see it and hear the powwow drum it always grabs onto my heart.

"I feel like Keith when I'm dancing—that it is just me and the Creator. Our lives are so hectic and I feel like that's my time for myself, for me. When I'm getting dressed, I'm dressing my spirit and I'm feeling young, I'm feeling really beautiful and I feel good about myself, that I'm somebody, that the Creator made me and I have a place in this world. I think that the only time I feel beautiful is when I'm dressed in my regalia. I feel that I'm the same as everybody else and I feel light and it's my connection to the spirit world. I always

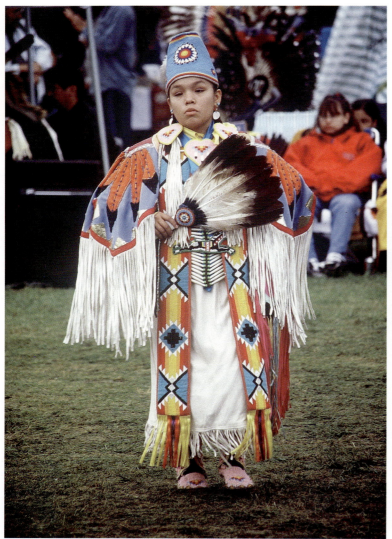

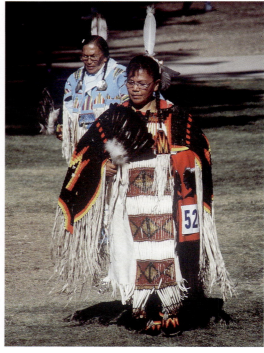

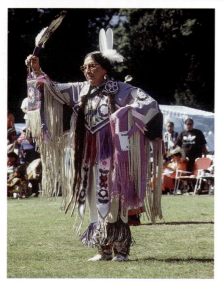

touch the fan to my heart when we're waiting in line for Grand Entry. I always have the eagle fan on my heart when we go in and I say, 'This is for you Dad,' or I say a prayer to my grandmother or for one of my friends, cousin or my sister. That's my connection to them because they're in the spirit world and we're entering the spirit world when we're entering the Grand Entry because the spirits are brought in with the flags."

Gloria and all the other Traditional Dancers move so quietly compared to the men but there is still the perfect timing with the drum. It is almost impossible to stop your knees bending just a little, or a whole lot, as unconsciously you try to capture the grace and the rhythm.

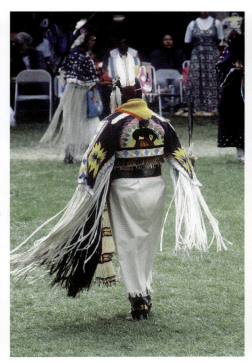
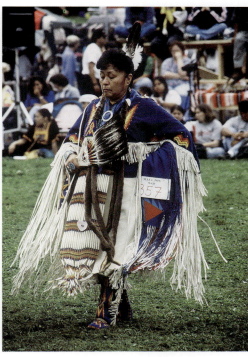
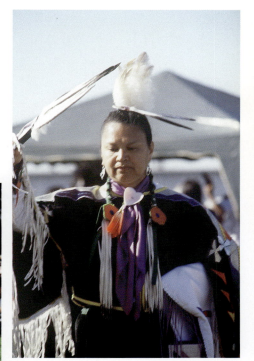

Capturing this rhythm, not to mention the grace, is not as easy as it may look. I remember being at Williams Lake with the Rural Teachers Association a few years ago and being invited to Alkali Lake to see some dancing. I was in my early forties and fit, I thought! An elderly couple in their early seventies came in and talked to us about the dances and then began to dance. They floated, light as air, around the gym. It looked so easy. We all got up to try the dance. In about five minutes (felt like 500) I thought I was gonna die! My legs were in agony and I was out of breath! We all had to sit down while, the elders continued to float around the gym, not even out of breath, for what seemed like forever! Easy? No!

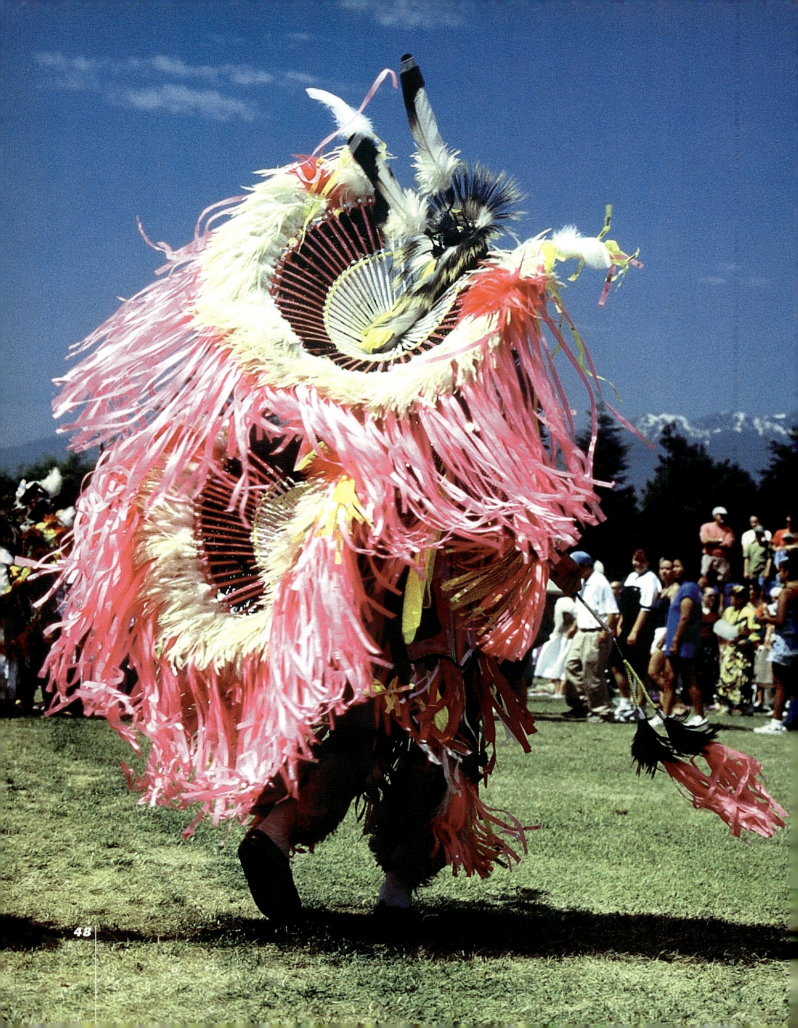

Chapter Seven

The Fancy Dancer—Sometimes called Dancer of the Rainbow

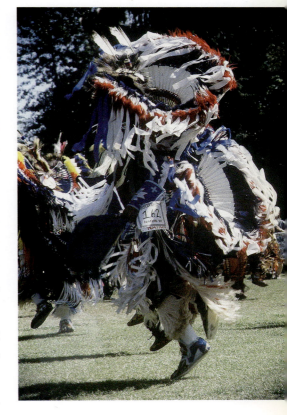

The Fancy Dance is not for the faint of heart or the unfit body. The high energy and strenuous dancing make this a young man's dance. The dancers move so fast they can blur into a rainbow of colors as they spin and leap their way around the arbor.

Today's Fancy Dance is a fairly recent version of the original Fancy Dance. The original dance was introduced after the Warrior Societies faded and the dances were opened up to everyone. The people from Western Oklahoma are recognized as the creative force behind the dance. They were introduced to what was called the Crow Dance in the late 1800s and inevitably began to introduce changes. They added more vitality to the dance by including leaps, turns and splits that would make your eyes water. The original crow belt, or single bustle, made from crow feathers and only worn by society officials, was also radically changed. Dancers began to wear more than one bustle at their backs and added small ones on their arms. Coordination of the regalia was created when color was added to the whole outfit. The crow feathers were replaced with variegated feathers such as pheasant and brightly colored belts and moccasins became part of the regalia. The Fancy Dancer had been born.

Today's Fancy Dancer, the one you see at the powwows, is yet another version. As stated earlier, dance is never static; creativity cannot be denied.

The young men returning home from World War II had a very strong influence on the way the dance and regalia evolved. The small bustles of the 1940s were now much bigger and large eagle or turkey feathers were used and "fluffies" (downy feathers) were added to the

49

feather bases and tips. Someone introduced dyed feathers, usually rooster feathers, in the 1970s and the dancers quickly incorporated them into their regalia. Plastic streamers arrived shortly after this and they were attached to the ends of the feathers. Bustles became bigger and bigger. The back view of today's Fancy Dancer consists of two huge eagle feather bustles, almost covering him from head to foot. The crow belt is a distant memory.

The old style headdress of two rows of upright feathers has also disappeared and been replaced by the roach and the bobber. The bobber is fascinating; as the name implies, it never stops moving. It's made of a wooden base that holds two feathers. The seesaw action, or bobbing, is created by rubber bands. The whole thing is held in place on the dancer's head by ties.

Dancer of the Rainbow is an apt description for today's Fancy Dancer. The leggings, bone breastplate, fans and twirlers are enhanced by the two large matching bustles, matching beadwork on the armbands, cuffs, belt, side ropes and moccasins. The dancer explodes into action. The style is fast, involving dramatic spins, intricate fancy footwork and continuous body movements. The bobbers, twirlers, bustle feathers and streamers are kept in constant motion.

The dancer is judged on his ability to keep everything in constant motion. He will also try to use as many tricks in his dance as the rules allow. However fast he moves, or how fancy his tricks are, he must be in control and stay with the drum. He must finish with both feet on the ground on the final beat.

There are a large number of good Fancy Dancers, so many that special "trick" songs have been written to help the judges determine a winner. Trick songs stop almost anywhere in an attempt to shake the dancer and cause him to misstep. He has to know songs intimately because he will be out of the contest if he misses a beat or fails to stop on that final note.

The dancer must be fit, super fit, to maintain the energy output needed for this dance. It is rare that he only has to dance once, sometimes he has to dance three times with the final one being a trick dance. His absolute concentration being one with the drum and the singing seems to create a special energy that allows him to keep going, even in temperatures of 35C (90F).

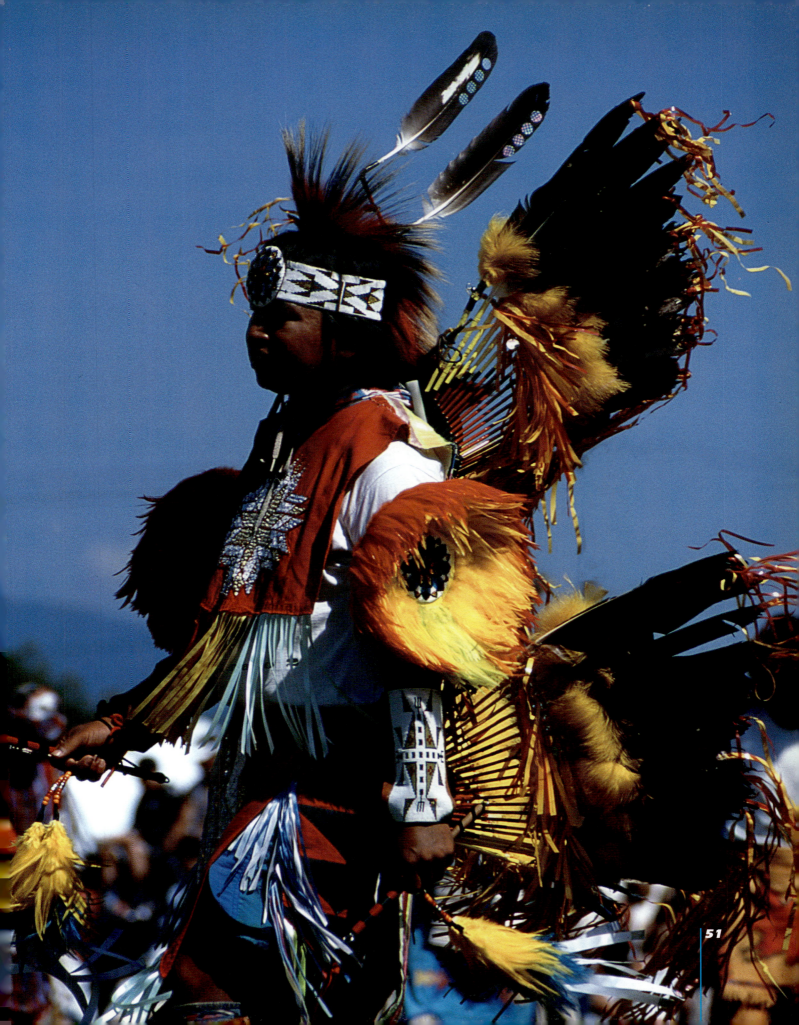

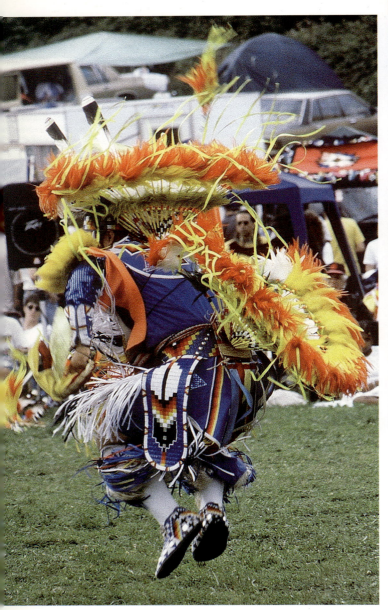
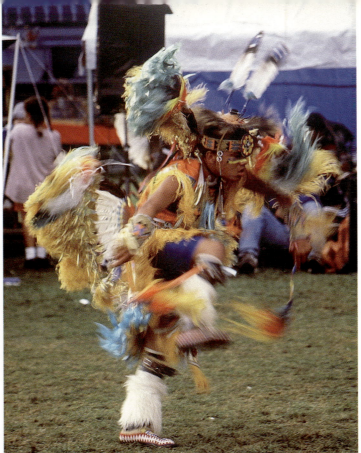

The Fancy Dancer, or Dancer of the Rainbow, is flamboyant and innovative. He is the spirit of the rainbow.

Freeland Jishie, Fancy Dancer, is a multitalented young man. We talked quietly in the longhouse at Humalchsun Park, and again later in Gloria and Keith's home, about his experiences as a dancer. "I come from Lukachukai, Arizona. It's in the northern part of Arizona by the Four Corners. I started Fancy Dancing when I was three years old. My uncle, Sam Yazzie Junior, was a World Champion Fancy Dancer at Firebird Park, Casa Grande, Arizona, and I guess I just wanted to follow in his footsteps. He was my inspiration. I wanted to be like him. Fancy Dancing is a big part of my family, so that's the

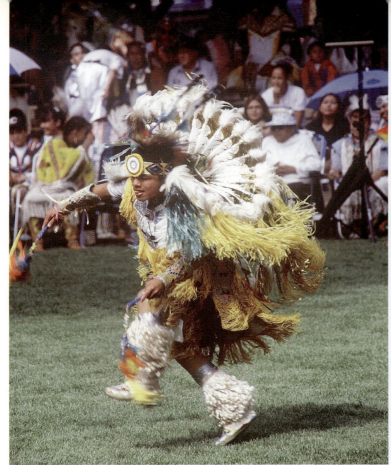
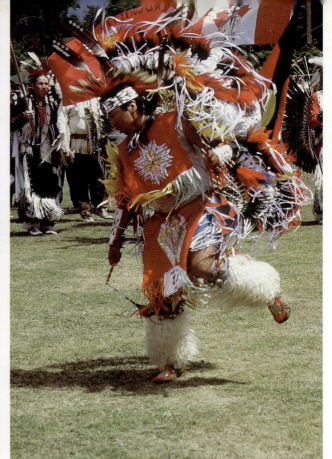
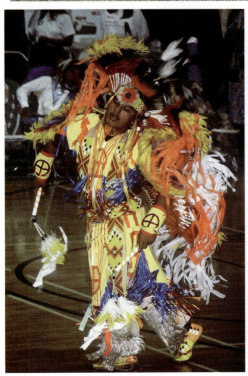
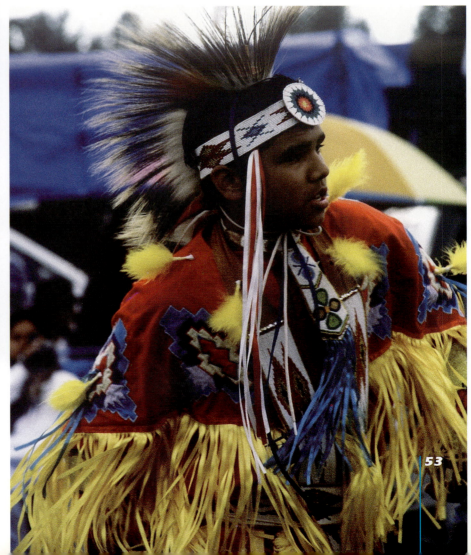

53

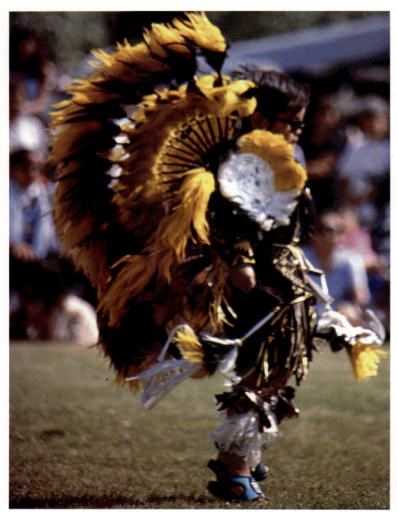
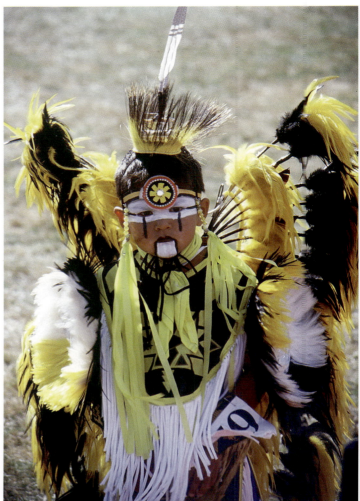

main reason why I chose Fancy Dancing and also because I like to dance fast. I prefer to dance Southern Fancy, which is faster than the Northern. My brother, my grandpa, my uncles and my cousins used to Fancy Dance, but they don't dance any more. I'm the only one left that really dances now.

"My outfit colors are red, blue and white and I really enjoy having those colors because they're my favorite colors. My bustles were made by Amos Yazzie from Chinle. All my beadwork was made by Virginia Yazzie, my auntie. I have always liked the design of the old-style regalia more than the contemporary style and I feel honored to wear my uncle's beadwork design on my own regalia. It really means a lot to me that he wanted me to carry on that design.

"I traveled to the southern state powwows when I was a young boy and then started to travel further afield as I grew older.

"My most special time as a Fancy Dancer was probably in my

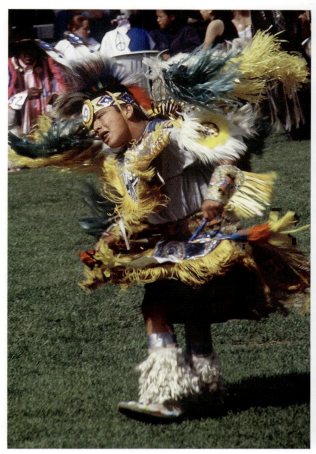
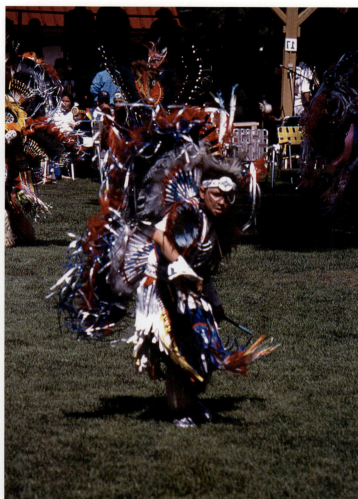

teen years because I traveled throughout the U.S. and Canada. I placed in competitions all over and I became well known because of my dancing. I was invited to so many exciting places—Fort Hall, Idaho; Whitefish Bay, Ontario; and Peguis, Manitoba, to name only some of them.

"The highlights for me were when I placed fourth at the Gathering of Nations in 1997 and when I placed first Consolation in the World Championships at the Mashantucket Pequot Nation Annual Schemitzun Powwow in Hartford, Connecticut."

I sat and listened to this young man talking to me quietly with his big smile and sense of humor and remembered how truly transformed he becomes in the circle. The drum begins and he flows into movement leaping and whirling, his feet barely touching the ground. Always focused, creating from within, Freeland the quiet young man becomes the Fancy Dancer, the Dancer of the Rainbow.

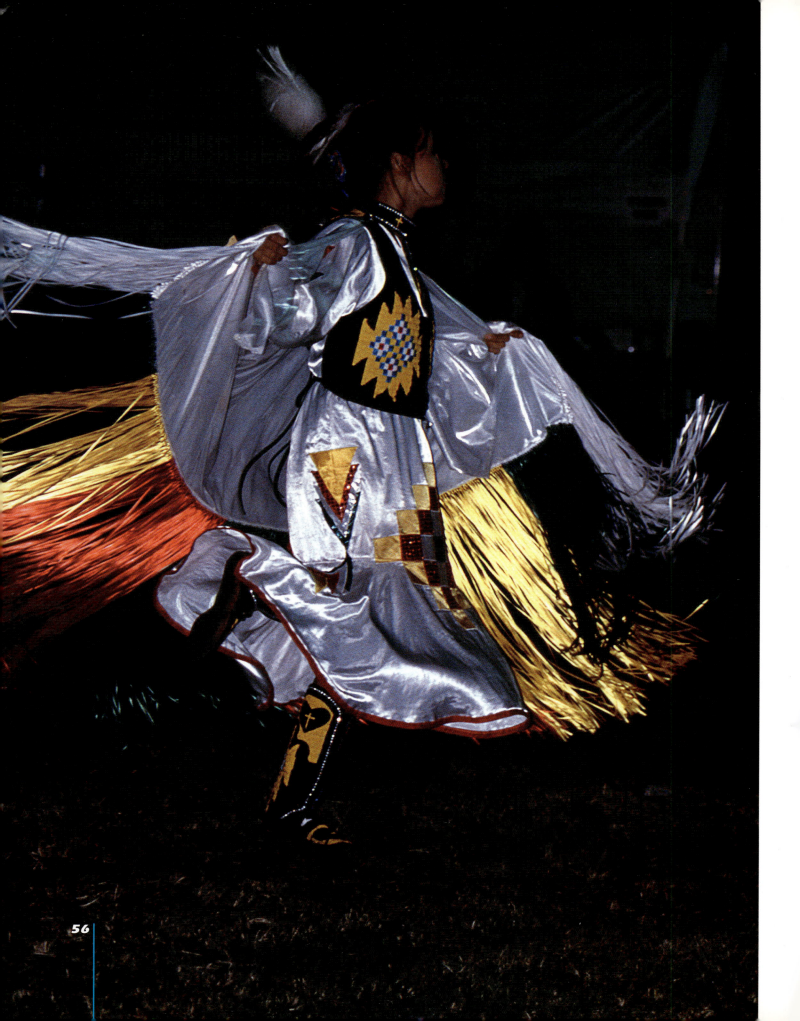

Chapter Eight

Fancy Shawl or Butterfly Dance

The Women's Fancy Shawl Dance is the newest addition to the women's dances. It is a Northern Plains dance but it crossed over to the Southern Plains in the 1970s or 1980s. There are records of women Fancy Dancers in the south in the 1960s and it is believed they competed with the men dancers; however, they were not Shawl Dancers. The dance may be new in comparison to many of the other dances, but it does have its own interesting legend.

Gloria tells the tale of how the dance got its name. "A butterfly lost her beloved mate in a battle. She grieved so much that she wrapped herself in her cocoon. She traveled all over the world stepping from stone to stone until, finally, she found beauty in one. The beauty touched her heart and allowed her to break out of her cocoon and begin a new life. She became a beautiful butterfly again dancing in the sun."

Some people compare this story to the changing role of today's women. Women were always very important in their culture; they were the mothers, close to the earth, the caregivers and leaders in their own quiet, strong way. Today many women are reaching out in different ways, still strong, mothers and close to the earth but being more visibly active in creating change. They too are dancing in the sun, like the Butterfly.

The Women's Fancy Shawl gives the young girls and women a chance to show how graceful and agile they can be. It is an energetic

57

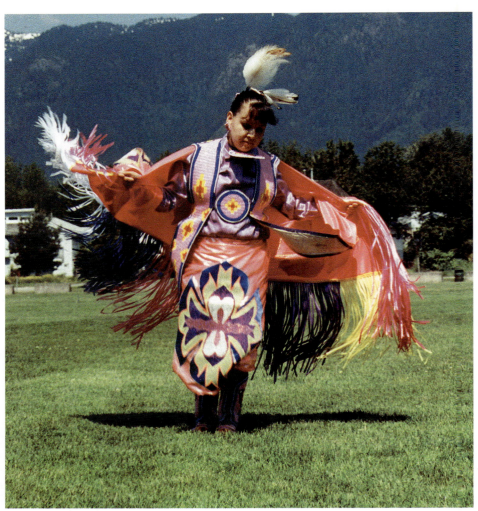
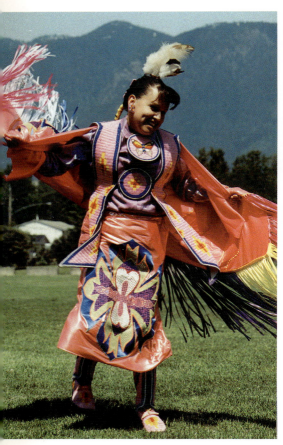

dance and because of this is similar in some ways to the Men's Fancy Dance. The women have to be very fit and flexible to maintain the speed and precision needed for this dance.

The shawl is an important part of the traditional dress. It is interesting to know that a woman is properly dressed and can enter the arbor if she is wearing a fringed shawl, even if it is worn over jeans, shorts or regular street clothes. Men do not have this option except in intertribals, honor songs, round dances and social dances. It is not surprising therefore that the shawl plays such an important role in women's dances.

The Fancy Shawl is used very differently from the shawls of the Women Traditional Dancers who carry theirs folded over one arm. The Traditional Dancer moves so that the long fringes on her cape and sleeves sway and move with the rhythm of a waterfall. The Fancy Shawl Dancer moves so that the fringes on her shawl and yoke whirl outward and around her as she dances.

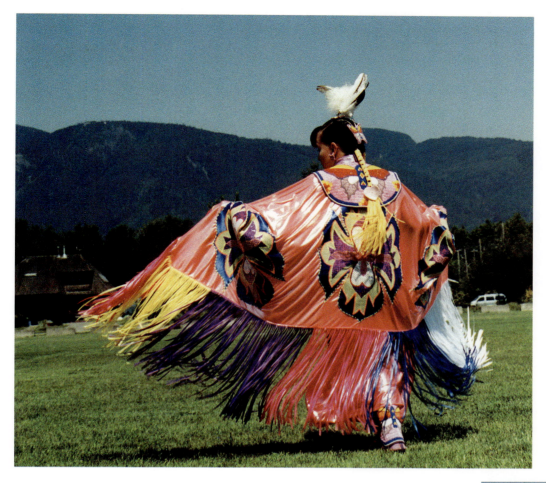

The shawl is the most striking part of the regalia. The designs are colorful and often designed and made by the dancer. Some dancers have different outfits and shawls but always have their personal symbol on all of them. The experienced spectator can often recognize a dancer by their symbol. Kanani Nahanee makes all her own regalia and always has her eagle as part of her design. The shawl design can be a mixture of colored materials that are oversewn with beads or sequins; the fringes can be all one color or a mix of colors matching those in the design. It is the most striking part of her regalia and it is also the most important as it represents the wings of the butterfly; it is held by tucking it under her arms. As she dances it billows out around the dancer, like wings, as she moves the shawl constantly, balancing to the left, then the right, using her arms to maintain control. The fringes ripple, fully extended and suddenly the design comes to life as she jumps and spins mimicking the flight of the butterfly.

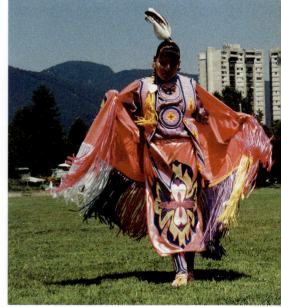

The fringed yoke is usually heavily beaded or covered in sequins.

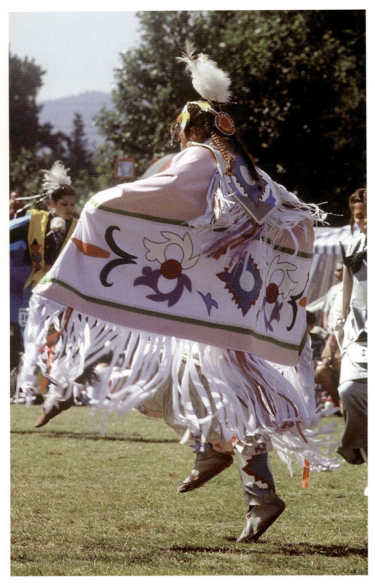

The designs are varied and individual; some use geometric designs, animals, birds or butterflies. The whole yoke comes alive in the dancing as the fringes move with the body and the beads or sequins catch and reflect the light. The dress under the yoke and shawl can be made from a variety of lightweight fabrics. Satin finishes are popular, but sometimes cloth or the traditional style buckskin is used.

Beaded disks, pendants or a headband and a feather, or feathers, enhance her shining, braided hair as her head moves with the song. Her moccasins are fully beaded but the leggings may be beaded or sequined. Both will have the personal symbols and designs seen on the yoke and shawl. These may be hard to see when she is dancing.

Close up you can see the dazzling, high-speed footwork performed as though her feet barely touch the ground. The full effect of her dancing, however, is really appreciated from a little farther back. It all comes together from there. The movement of the shawl, the fringes, the sparkle of the sequins on the yoke and leggings and the elegant, quick footwork do indeed look like the butterfly coming alive in the world.

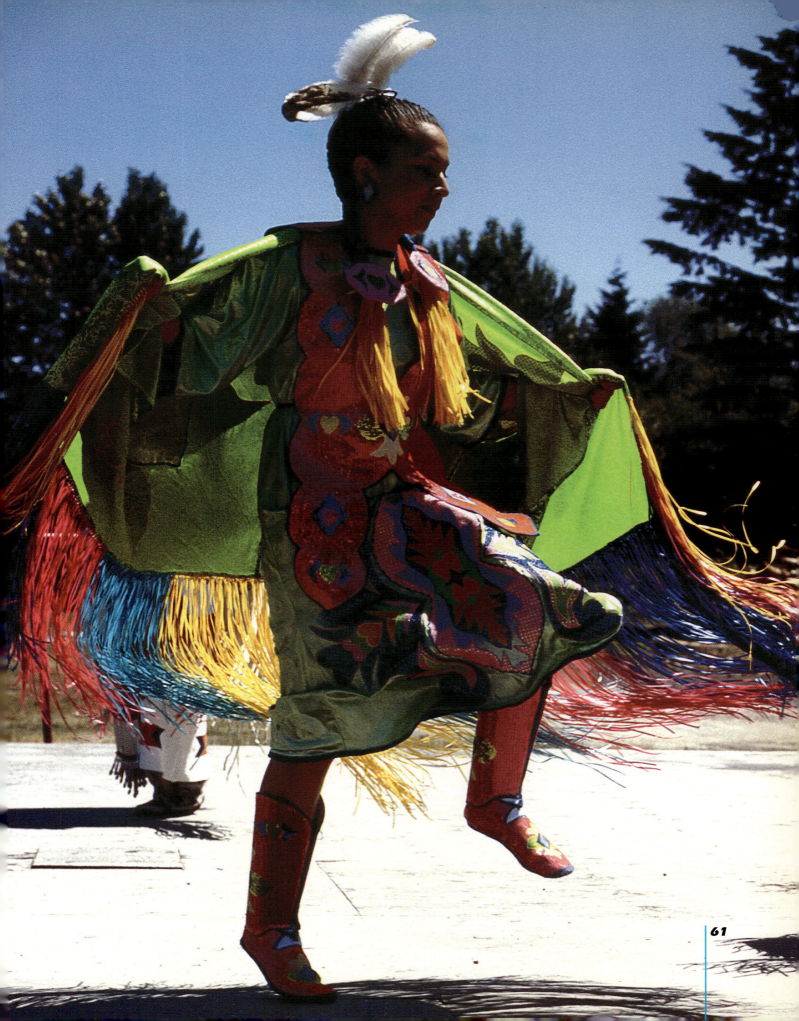

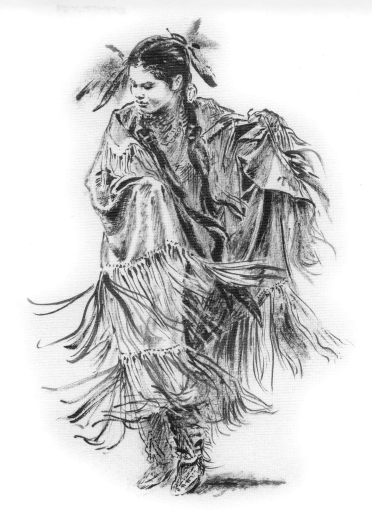

The judging of the dancing is similar to the other dances in that the dancer has to stay on the beat of the drum and finish on the beat. Trick songs are also used for these dances, so familiarity with all the songs is essential. Even when the drum beats faster and faster she must stay in control of her feet and body movements to maintain the sense of rhythm.

The judges look for other special things in this dance; they look for the gracefulness and agility of the butterfly and a sense of harmony created by the movements of her shawl of her whole body rhythm with the music.

Kanani Nahanee began dancing when she was six years old. "My mom, Gloria, would take Riannon and me to Cedar Cottage every Monday evening to watch and take part in the dancing. We started out wearing paddle dresses, the traditional Coast Salish regalia, for the Grand Entry at our first powwow at Trout Lake in 1986. I love to dance—it makes me feel good. If I don't dance for a couple of weeks I find myself saying 'I need a dance, I need a dance.' It's a way of

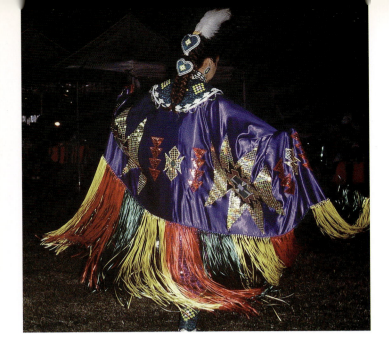
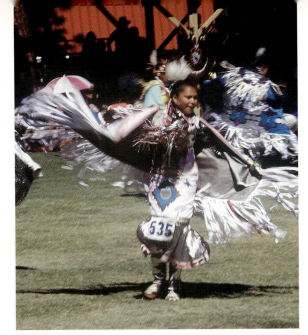

relieving my stress, my tiredness. I get really tired and burnt out after I dance, but it's a good feeling. I like having that feeling.

"I make my own outfits. I just picture them in my head first before I make them. I use geometric designs, but my new outfit is gonna have a butterfly on the shawl for a change. Everybody always says, 'Kanani, you always have eagles on your outfits.' It's true; I do mostly have eagles because they are my favorite.

"The main part of my regalia is the shawl because the dance is called the Women's Fancy Shawl. The whole outfit is the shawl, yoke, leggings, moccasins and the dress. I design my outfit, choose the material do the sequins and all the sewing, except for the beadwork. One of my friends, Pam Pompana, does my beading for me; she does such beautiful beadwork. The Shawl Dance represents the story of the butterfly who lost her mate and she went into her cocoon to mourn. When she came out, she had recovered and was dancing; she was light and graceful. When you dance the Fancy Dance, you're supposed to be graceful and light and just look like a butterfly.

"The first thing the judges look for is the footwork and the coordination. Keeping time with the drum and finishing on the beat is really important. You really have to know the songs and pay attention. The trick songs that are used when the judges are having a difficult time deciding are really hard; they are so fast and you never know when they will stop or have a long pause so that you think they have finished. The dance outfits kind of come last in the judging.

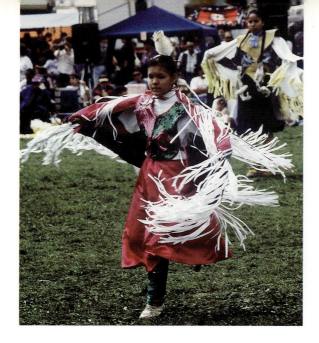
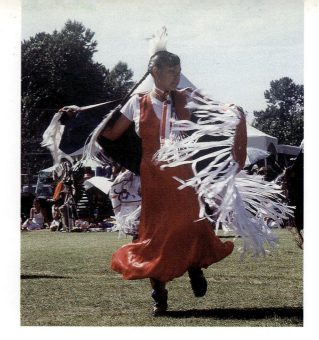

"Everybody has their own style when they make their outfit. You can usually tell who made the outfit by the style of it, even from a distance. People recognize my designs by the shapes I use, the designs and the eagle; they all fit together in my style. I have my own 'look.'

"The most exciting and wonderful time for me was when I took first place in the Teen Girls Fancy Special event at the Gathering of Nations Powwow in Albuquerque, New Mexico. It was awesome! I've always worked so hard at my dancing ever since I was young. I practiced dancing every day and did all the sewing, so winning made me feel as though it had all paid off. While all my friends were out partying and out on weekends at the mall I would be at home practicing or sewing on sequins, watching videos of myself to see how I could improve.

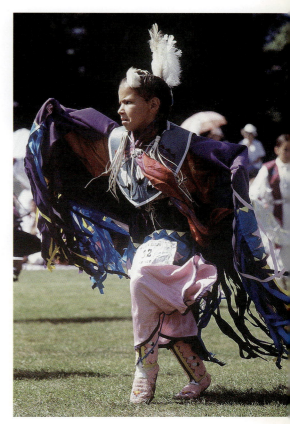

"Another very special time for me was in 1996 when I was asked to be Head Lady Dancer at the Aboriginal Cultural Festival Powwow in Vancouver. I felt very honored to be asked to hold such an important position.

"After my son Sheldon was born, I was too busy to take time to practise and go to the powwows to dance. I really missed the dancing but I had to wait until he was a little older. I started practicing again in November, 1999, but that was the first time in a long time. It felt really good. I was surprised because I'm not in any shape and I did five songs without getting sore or anything. Sheldon keeps me in shape; I have to run around after him all day. I can tell already

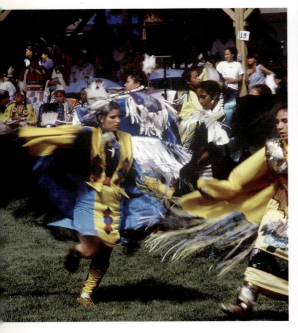
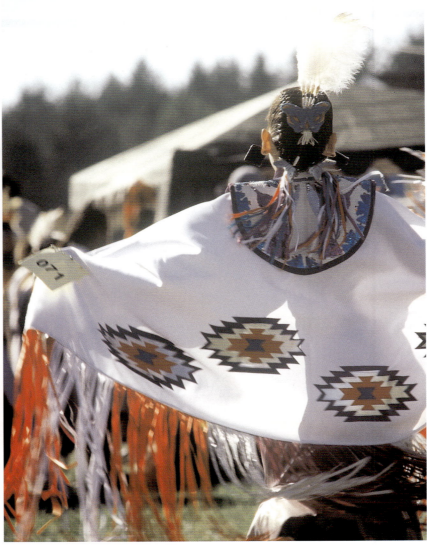

that he is going to be a good dancer by the way he moves to music. You should see him dancing to the drum! His dad, Freeland Jishie, is a Fancy Dancer too. Dancing has to be in his genes.

"I really got back into dancing this year (2000) and I'm feeling fit again. I'm making new outfits and competing. I went down with my mom and dad to The Gathering of Nations Powwow and to the Palm Springs Casino Powwow when mom was the Head Lady Dancer. I travelled with my best friend, Rose, to Saskatchewan to compete at Onion Lake Powwow and several others. I did really well and won or placed at most of them. I dance at almost all the B.C. and Washington State Powwows, Cedar Cottage, Kamloops, Skwlax, Songhee, Duncan, Nooksack. They are great to go to because we all travel together, Sheldon, Riannon, her children Donovan and

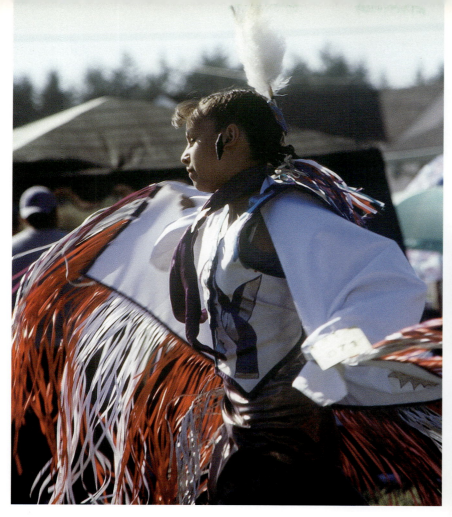
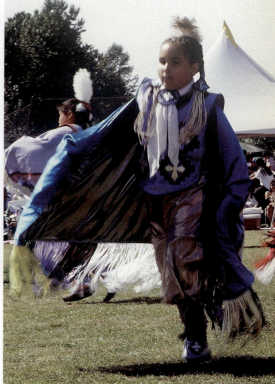

Kenesha, Mom, Dad and sometimes my grandmother, Maizie Baker.

"Powwows are more than dance competitions, they are a social time for me too. I visit with my friends; many of them are from far away so we only see each other at powwows, which is where we originally met. Most of all, I feel really good about myself when I'm dancing. I go with the song and the rhythm of the drum until we become one and my feet seem to fly above the ground. It's a way of relieving my stress and I feel fresh and energetic after I dance. It is a good feeling."

Kanani is now back into her serious competition dancing and travels quite extensively to compete. It seems to have taken very little time for her to regain her status as one of the best Fancy Dancers. She credits her fitness to trying to keep up with her son, Sheldon. Having met him quite often I'm inclined to agree with her; he is a little ball of fire and rhythm.

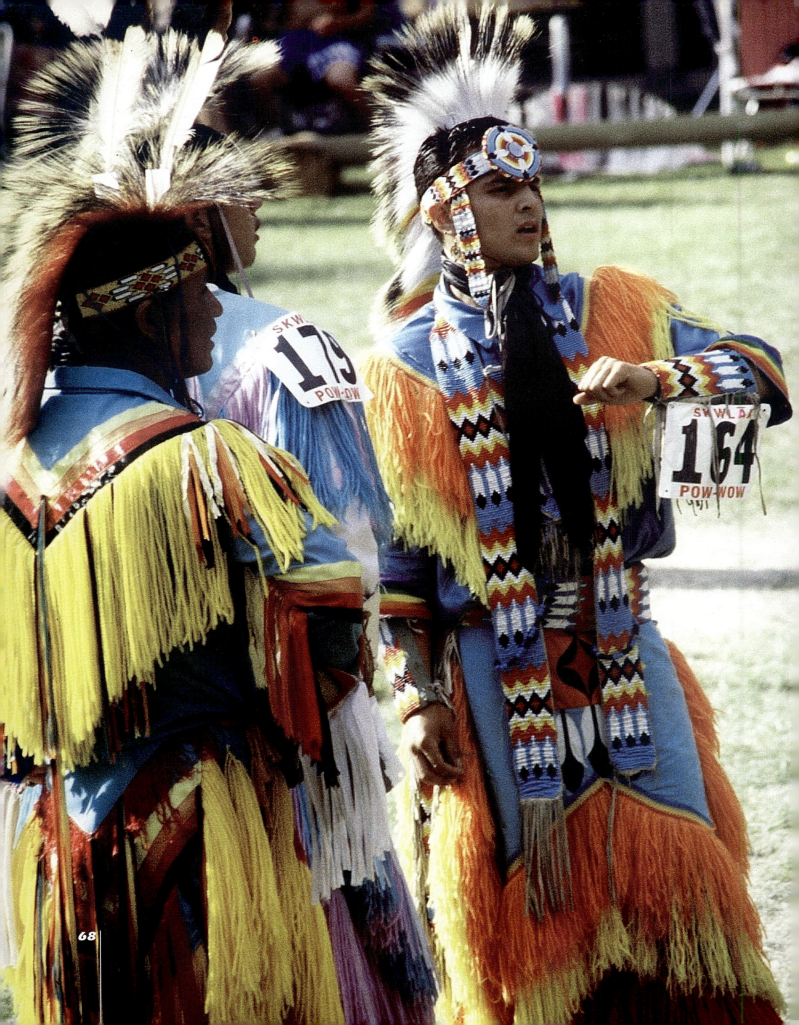

Chapter Nine

Grass Dance (Northern Style)

The original dances by the Warrior Societies were called Grass Dances and were only for the members of their own tribes. The Grass Dance itself is one of the oldest dances performed at the powwow. It is often called a War Dance and does retain some aspects that would celebrate victory, but it also seems to include actions from animal and bird dances. The original symbolism seems to have become lost over time, and although most of the old ceremonies are no longer performed the Grass Dance lives on.

Long ago it is said that the old-time Grass Dancers had to prepare their own arbor for dances by weaving and turning their way through the tall grass, dancing the grass down until it was flattened like a blanket on the ground. They moved like the grass in the wind; some said it was the spirit of the grass rippling and whirling through the dancers. The tradition continues as today's Grass Dancers are still called into the arbor to prepare the ground before the powwow begins, although there is usually no tall grass to flatten.

The time came toward the end of the nineteenth century when people who were not members of the Warrior Societies were allowed to participate in the dances. A more social kind of powwow emerged while at the same time people began to travel more so that dances were carried from tribe to tribe. The Omaha introduced the dance to the Lakota of the Northern Plains who as a sign of respect referred to it as the Omaha Dance, it was also called the Grass Dance because of the braided sweet grass worn in the bustles. The North Dakota dancers of the early 1900s were the forerunners of the Northern Dance style and regalia of today. The dance of those days, however,

69

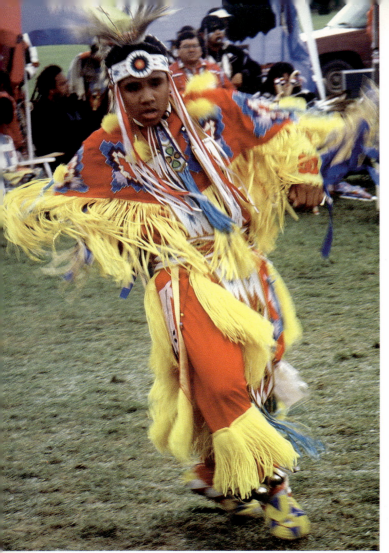
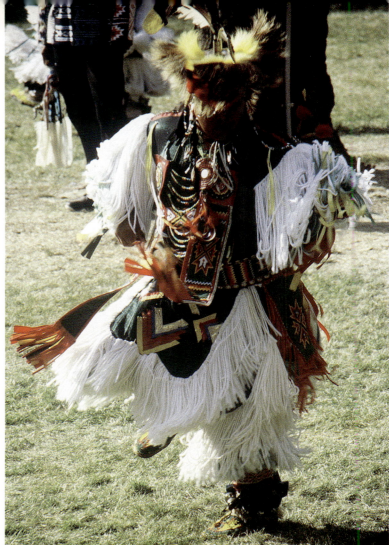

bore little resemblance to the Northern Grass Dance of today. The old-style post-Warrior Society Grass Dances were social events that gradually evolved into the powwow we know today. Contest dancing appeared in the 1920s and quickly became popular, spreading throughout the various tribes. Dance rarely remains static in form, so it was inevitable that the Northern Plains dancers gradually made their own innovations. No doubt they would be surprised if they could see how the dance evolved yet again into today's high energy, colorful Northern Grass Dance. It's a far cry from the original but the roots are strong. The dance is still shifting and changing in subtle shades, just like the grass it is meant to represent.

Tracking the history and development of this dance was fascinating because it is so old and yet it is so new. I thought I had finally tracked my way through all the debates about and references to the meaning and origin of the dance and was feeling quite confident in printing what I had discovered. Somewhere, however, there always

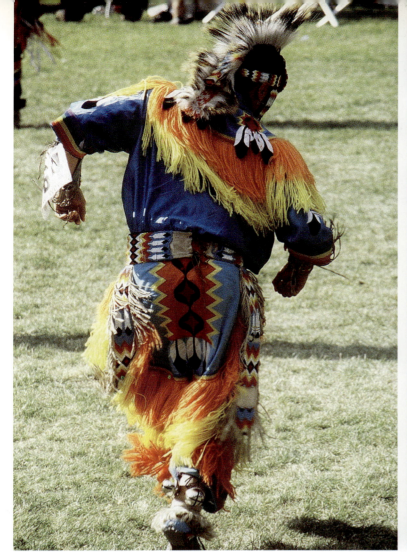
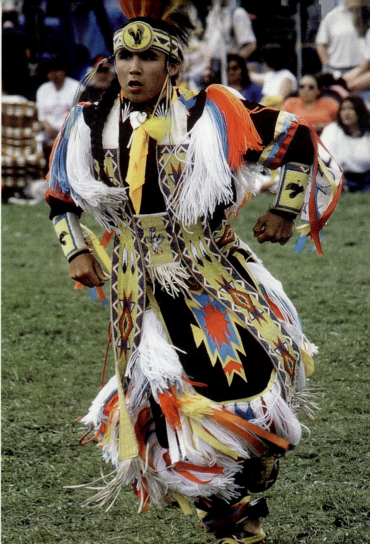

lurks inside a nonfiction writer an underlying concern that despite careful research into recorded history and reported transitions and stories that someone new will show up with a somewhat different version of all, or part, of the history.

Fortunately, I met Jon Olney, champion Grass Dancer, before anything was in print so I was able to listen to his wonderful history of the Grass Dance without major trauma. Instead I had the opportunity to add his knowledge to mine and present it here. Jon shared what he knew of the history as we sat together in the dusk of a very chilly evening at the Nooksack Days Powwow.

"Glen Little Wolf of Onion Lake, Saskatchewan told me this history of the Grass Dance. It is the oldest dance, originating with the Warrior Societies; it came to us from the Omaha tribe. The dance spread as a gift to a family in Fort Berthold, North Dakota, from there it moved west to the Cree, Blackfeet and the Gros Ventre.

"It was the heart of a healing ceremony; it was a healing dance.

The dancers would sit in groups in the four directions with the sick person on blankets in the center of the arbor. They would all fast and pray for the sick person to be healed, then the drum and singers would begin by singing four songs. The dancers from the east would be the first to move in toward the ill person. They would dance around him or her, brushing the body with their fringes that were used to absorb the sickness and take it away from the body. The drumming and singing would continue until the dancers from all four directions had danced around the sick person, brushing and cleaning away the sickness. In those days the dancers wore buffalo horns with fluffs on the tips, which they shook as they danced. The horns were meant to represent insects that were believed to be strong and to have the ability to carry away the sickness brushed from the body by the fringes. That is the history I know of the Grass Dance."

Because the Grass Dance has its roots deep in the past and is known by many names, it is interesting to trace its development over time from ritual to popular dance. The origin of this dance is frequently debated. Jon's history introduces some very interesting details regarding the dance as a healing ritual, but that aspect seems to have totally disappeared today. No doubt it is one of many very interesting versions of the Grass Dance out there which have been passed on orally to preserve its history.

Time has passed and today the dance has returned once more to the south bringing with it the "new" Northern style, which in turn has been a strong influence on today's Southern Grass Dancers. There are no longer new traditional war experiences to portray through the dance. Therefore, each dancer creates his own choreography for enjoyment and to exhibit his expertise. Dance knows no borders of time or geography.

Grass Dancers have not only changed the dance moves over time, but they have also changed their regalia. They no longer wear bustles, because they interfere with their elaborately fringed yokes. The regalia is colorful, decorated with grasslike fringes made from strands of ribbon, yarn or fabric sewn on to V-shaped yokes and leggings. The headgear, called a roach, is usually made of brightly colored porcupine and deer hair, eagle feathers or fluffy plumes, feelers, ribbons

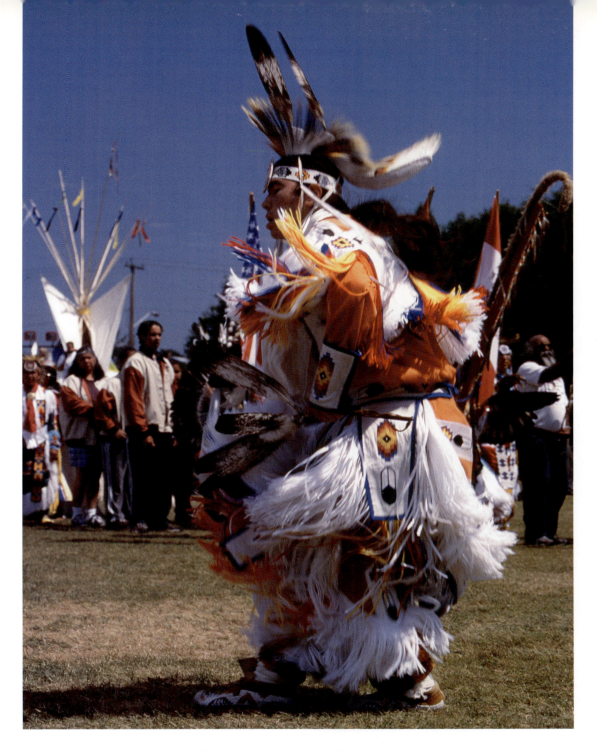

and beadwork. Beaded headbands, harnesses, cuffs, moccasins and breastplates complete the color and design coordinated outfit. Many dancers design and make their own regalia incorporating their personal and spiritual symbols. Others have regalia that has been handed down through the generations. Their regalia seems to flow as they move in perfect time to the music, like the grass moves with the wind. No two outfits are ever the same; no two dancers are ever the same.

The Grass Dance is a way of expressing the harmony of the uni-

verse and the balance of life; each movement on one side of the body must be counterbalanced by movement on the other. The flow of the dance and the precision of the footwork must be synchronised with the song and the drum. All dancers work hard to accomplish this balance by listening to tapes, learning the songs, (especially the trick songs), so that they do not overstep on the last beat.

Jon Olney speaks of his growth as a Grass Dancer with a quiet passion and modesty. He is a tall slender young man who really does move with that inner sense of harmony and balance. "I started dancing when I was twelve years old. My uncle, Lester Lewis, was a Grass Dancer. He was a major influence in my life and I wanted to be like him. I had to be a Grass Dancer. He taught me his own special steps and gave me my first regalia. My life became focused on dancing from that time on.

"I joined the longhouse in Whiteswan at the same time as my mother, Lenora Lewis. We had to work together for a long time to get ready for this special ceremony as it involved a Give Away and we had to make sure we had all the gifts ready. It was a very special time for my mother and me.

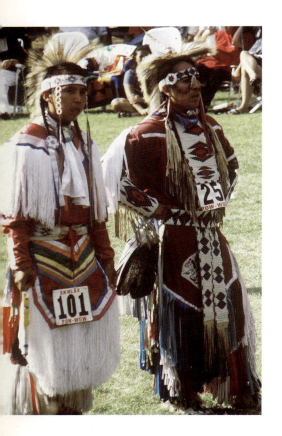

"It was not the only special time though. In 1998 we shared another ceremony—this time it was a naming ceremony. I had to give away everything I had with me. It was like walking down a long runway lined with people; by the time I got to the end I was down to my shorts. I was then given my name, *stixmi paxumtla*, Grass Dancer, by my Aunt Tootsie (Roberta) Danzuka. Aunt Tootsie made and gave me my new dance regalia, which is the one I wear now. I have the eagle as my special symbol and it is beaded on to my headband and cuffs.

"When I first started to dance, I worked all day, even when I took a break I was watching videos of Grass Dancers and myself, listening to tapes of the different drum groups and learning their songs, especially the trick songs. I had to work really hard to remember them so that I would not overstep on the last beat. I create some of my own steps and combinations just like my Uncle Lester Lewis. Then I have to practice until they just flow almost without thinking, they have to become a part of me."

Jon was World Champion Grass Dancer in 1996 at the

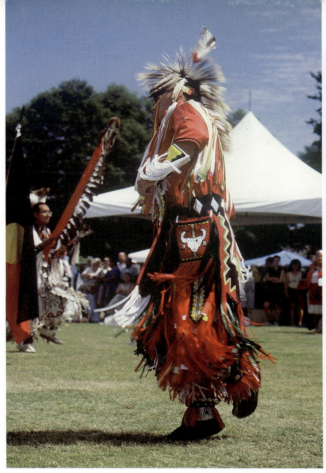
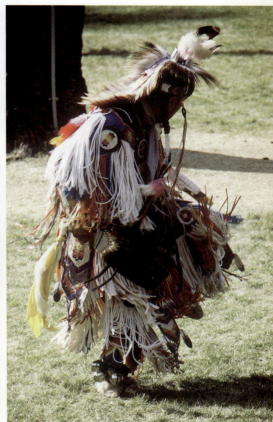

Mashantucket Pequot World Championship of Song and Dance. In 1999 he was All-Around Champion at Kamloops and second at Chilliwack. Winning championships is exciting and a way for his peers to let him know of the high regard they have for him and his dancing, but it is very obvious when speaking with him that it is the act of dancing that gives him joy.

"I love to dance it makes me feel happy and connected to my past, my family and the Creator. I become one with the drum and the Mother Earth when I dance. I like to think that my dancing brings happiness to others too."

Jon has just begun his first year at university; he plans to go into forestry and then work for his tribe. He was not dancing at Nooksack Days because of a leg injury, but he should be back on those lightning feet now. If you recognize him go up and speak with him. He is a delightful young man and you will enjoy talking with him.

Today's dancers each have their own unique style. Like Jon they work hard on new steps and combinations. Enjoy watching them, soon you will recognize the individual dancers by their moves and special personal touches to their regalia.

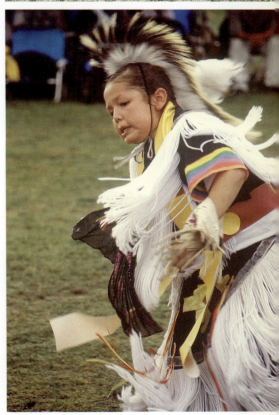

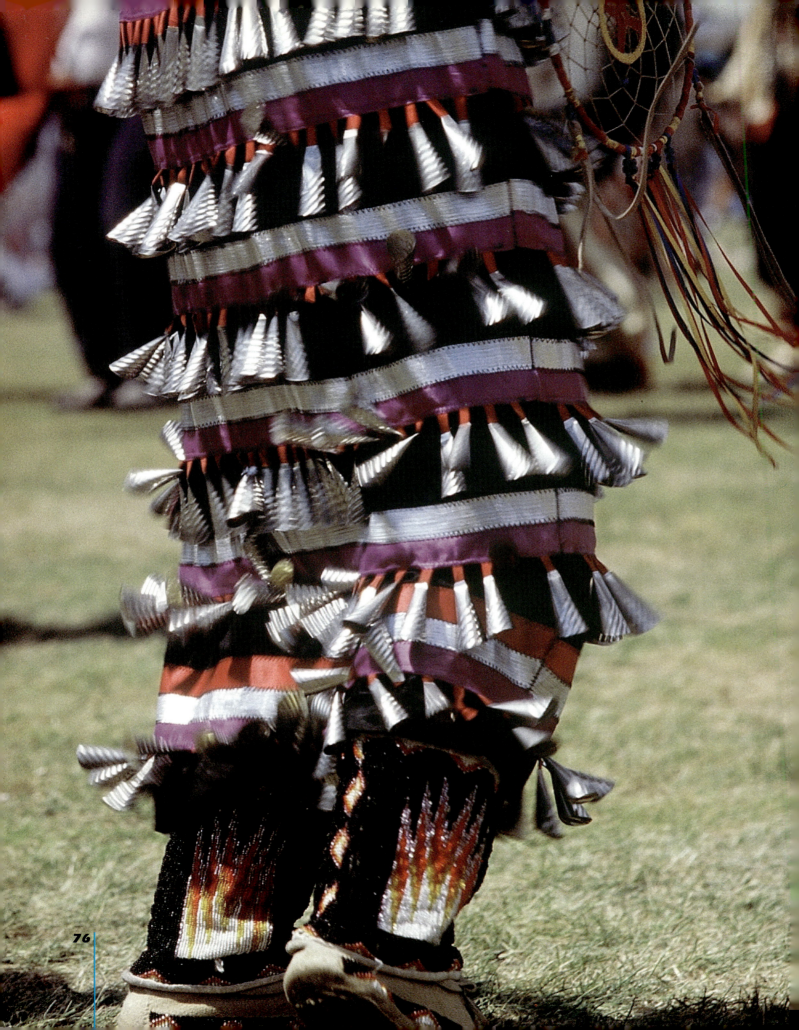

Chapter Ten

Jingle Dancers

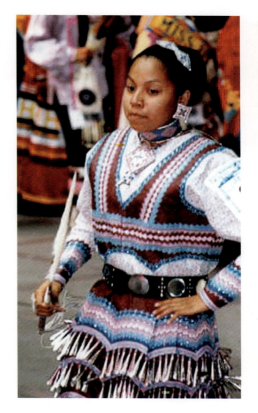

The Jingle Dancers can be heard long before they appear in the arbor during the Grand Entry. Heads turn as the dancers enter, their jingles moving and catching the light as they perform their intricate footwork in time with the drum. The jingles create a sound like rain and more airy than the hooves and bells worn by the men dancers. They are made of lightweight shiny metal that is easy to roll into shape; snuff can lids are often used as they can be rolled into cone shapes and sewn onto the dresses close enough to each other to touch and make their unique sound. Some dancers will have up to 600 jingles on their dresses. The dresses themselves are made from fabrics strong enough to withstand the constant movement of the metal jingles, so velvet, cloth and sometimes leather seem to be the favorite fabrics chosen by dancers. The dress is not really designed for sitting down, so the dancers have either another lightweight lining, or shorts, underneath so that they can hitch up the jingle overdress and sit down in comfort. The rest of the regalia consists of an eagle feather fan, beaded moccasins, leggings and plumes in her hair. A single feather or plume usually means a female dancer is single, a double means she is married; this is not unique to Jingle it applies in all women's dance categories.

The dance steps are fast and intricate, but despite that they retain an air of control. This dance reminds me somewhat of Irish dancing in that most of the body action occurs from the knees down. The overall movement is a zigzag combined with some turns and is meant to represent the pattern of life with its changes of directions while still moving forwards. The Jingle Dancer uses her fan in the same way as

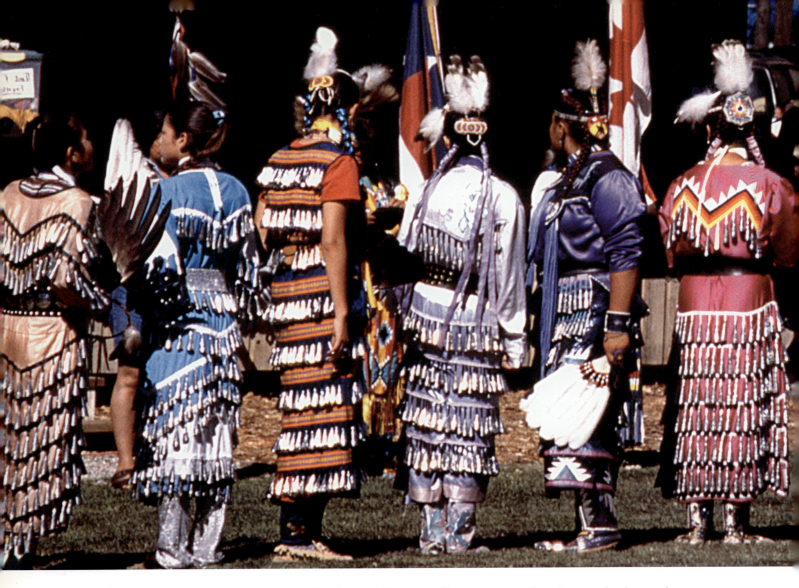

the Traditional Dancer. She too raises her fan on the honor beats.

The Jingle Dancers, like every other category, must start on the beat of the drum and finish with the last beat. The trick songs are very fast. It's impossible to disguise a missed beat in this dance, those jingles give you away every time and overstepping, finishing after the last beat, means you will not place.

The dance and dress style seems to have started in the 1900s when women began to take a fuller role in the powwows. There are several versions of the actual origin of the dance. Gloria tells this story. "There was a young Ojibway girl called Maggie White who was so sick she was dying. Her grandfather was a medicine man and had tried to heal her without success. He prayed to the Creator for help and asked that her life be saved. His answer came in a dream. A Spirit Dancer wearing a jingle dress, some people say it was four women in jingle dresses, told the medicine man to make his grand-

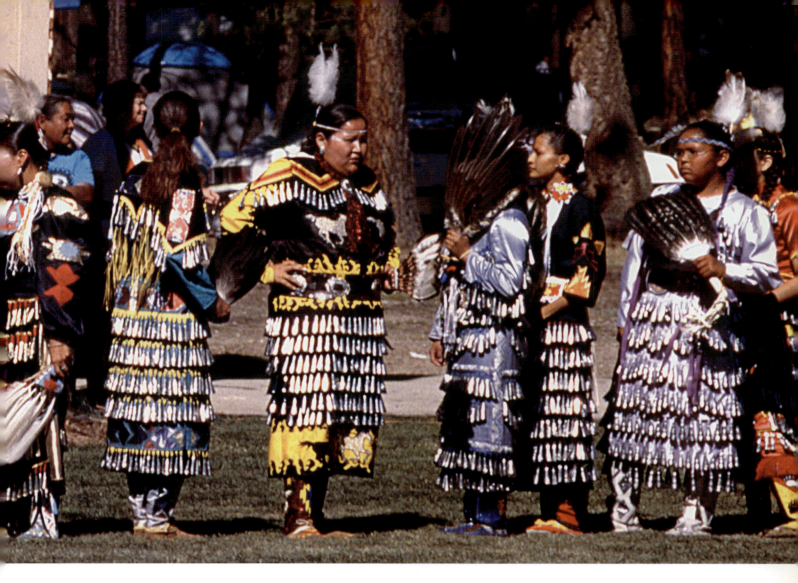

daughter such a dress and when she wore it she would be healed. He made the dress and put it on his granddaughter. At first she had to be carried because she was weak, but she got stronger and stronger until by the third time round the circle she was completely healed."

Jingle is a healing dance, a woman's dance of life, full of sound, flashes of light, zigs and zags. The dancer always seems to carry with her a sense of inner power, or control, to move forward and learn from those zigs and zags, both in her dancing and in her life.

The story of the Jingle or Medicine Dress is told in slightly different forms by many dancers from all over North America. Tahnee Marie Williams, a Jingle Dancer, is a close friend of Kanani; she includes her version as she shares her experiences as a dancer. "I am seventeen years old and I live in Tempe, Arizona. I am of Apache and Navajo descent. I started dancing the Fancy Shawl style when I was five years old, but I decided to change to Jingle

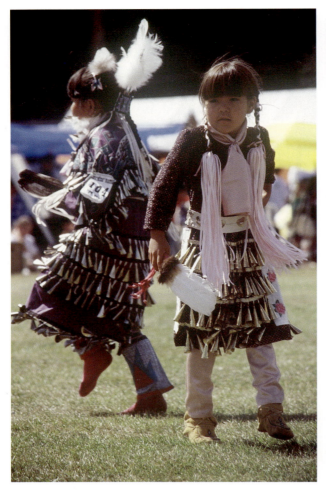 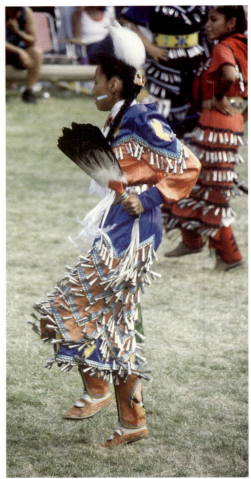

Dress style about five years later. I changed because I really admired the style and the way the dress moved and sounded. The Jingle Dress originated with the Anishinabe people and is considered to be the Medicine Dress. It is called the Medicine Dress because long ago an elderly man became very ill and as he slept he had a dream and a vision of this dress with metal cones, which made noise as it moved. He woke up from this dream and told his daughter to make this dress, which she did. When the dress was finished, her father was cured from his illness.

"I was brought into the circle as a Jingle Dress Dancer in July, 1994. My family became very close with the White family from Whitefish Bay in Ontario, Canada. We wanted me to be a Jingle Dress Dancer the right way; we wanted it to be official. We traveled to the Whitefish Bay Summer Powwow and I was initiated there. There were a pipe ceremony, honor song and giveaway and two elderly women Jingle Dress Dancers, Victoria Jack and Agnes Paul,

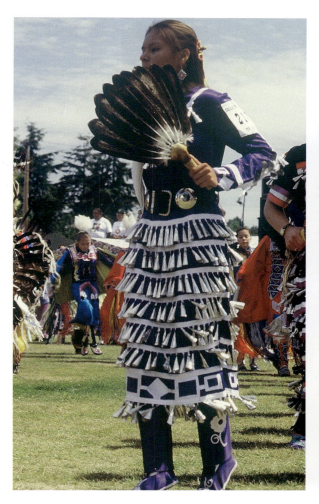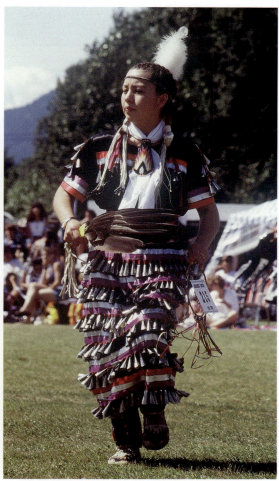

danced with me into the circle. The Whitefish Bay Singers made it even more special by composing a special honor song for me.

"Dancing makes me feel special and unique, especially since I dance Jingle, the Medicine Dress dance. I dance to make my family proud and to make other people feel good, I dance for those who are not able to. When I dance, I feel like I am in my own world where nothing is wrong and everyone is happy. This is a wonderful feeling.

"My whole outfit, which includes my dresses, beadwork, belt, fan and plumes, is a family effort. My mother designs and sews my dresses, my father rolls and puts the jingles on the dresses, my brother puts together my plumes and made my fan and I bead my moccasins, chokers and hairpieces. I would not be able to dance without my family. We all work separately on the outfit but then it all comes together beautifully in the end.

"I have had many wonderful experiences dancing and many accomplishments. At first when I started dancing I only attended

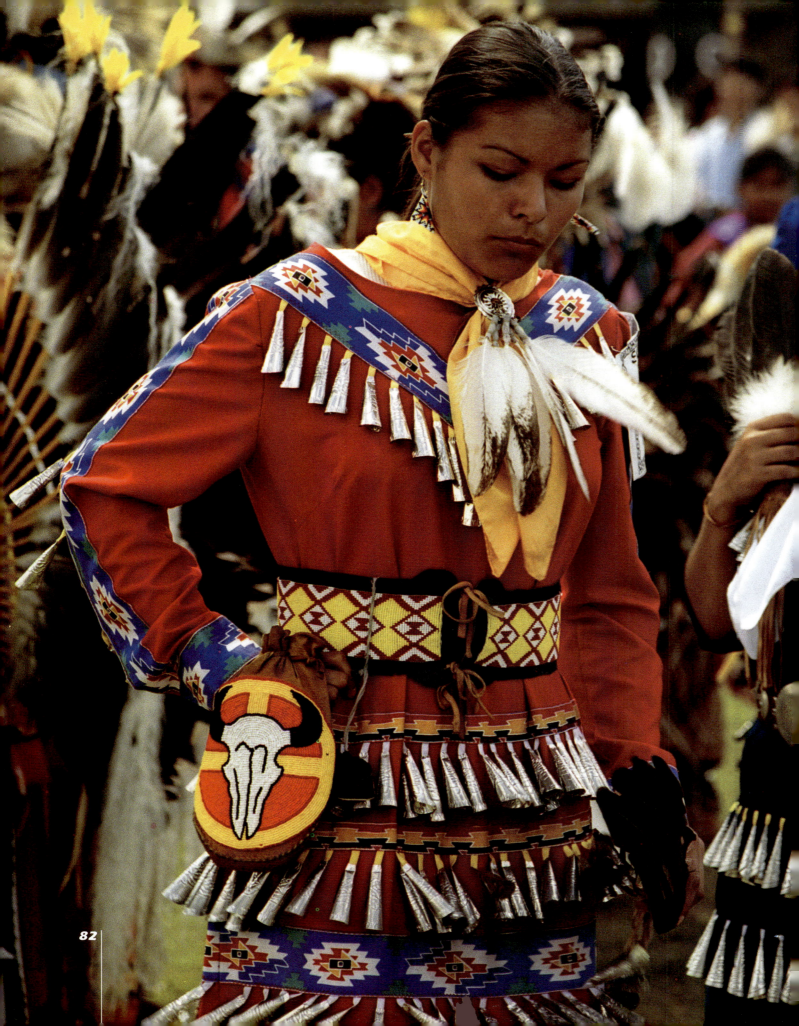

powwows close to home but as my dancing began to improve I began to place at various powwows and I eventually began to travel much further away to dance. I made my way up north and into Canada; I even traveled out to the powwow at Mashantucket in Connecticut. I have attended the Gathering of Nations Powwow since I first started out dancing, so it was very special for my family and me when I was selected to be the Head Young Lady Dancer at the Gathering of Nations Powwow 2000. It was such a great honor for me and my family was there to witness it; it was great.

"I think my biggest accomplishment is meeting new people. As I have traveled the powwow trail I have met wonderful people and now I have friends all over the country. Some families have adopted me as their daughter, which makes me feel awesome. I was also very fortunate to have one of my nicknames used as the official name of a Jingle Dress song. This song was composed by the Eya-Hey Nakoda Singers, a drum group I have become very good friends with.

"Not only am I involved with powwows but I have had my own traditional ceremonies. The woman plays a very important role in the Apache and the Navajo cultures. Both have a Coming of Age ceremony that is the story of creation. Both ceremonies have a test of strength and endurance and are designed to prepare me for my life as a woman, so that I will be blessed throughout the course of my life.

"I strive to conduct myself with honor, dignity and respect at all times. I take great pride in the fact that I had these ceremonies; it was an awesome accomplishment."

I "met" Tahnee via the internet, I would have loved to fly down to Tempe and meet her personally, but maybe we will meet face to face soon.

Kanani asked Tahnee if she would be willing to represent the Jingle Dress Dancers, because this is all about the Nahanee family and their friends, whether or not they live close by. We were delighted when she agreed to take the time and write for us. Tahnee's sparkle comes through even over the internet. She will graduate this year and head off to college. We wish her well and look forward to seeing her flash those jingles at many more powwows.

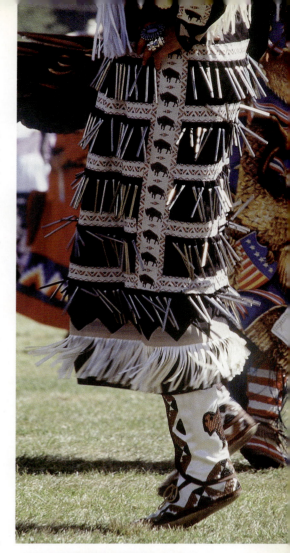

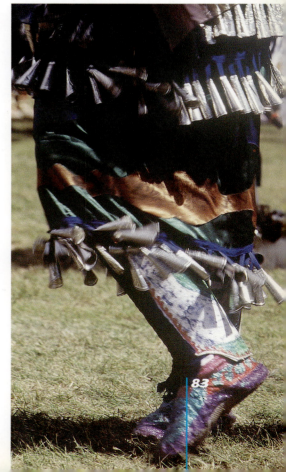

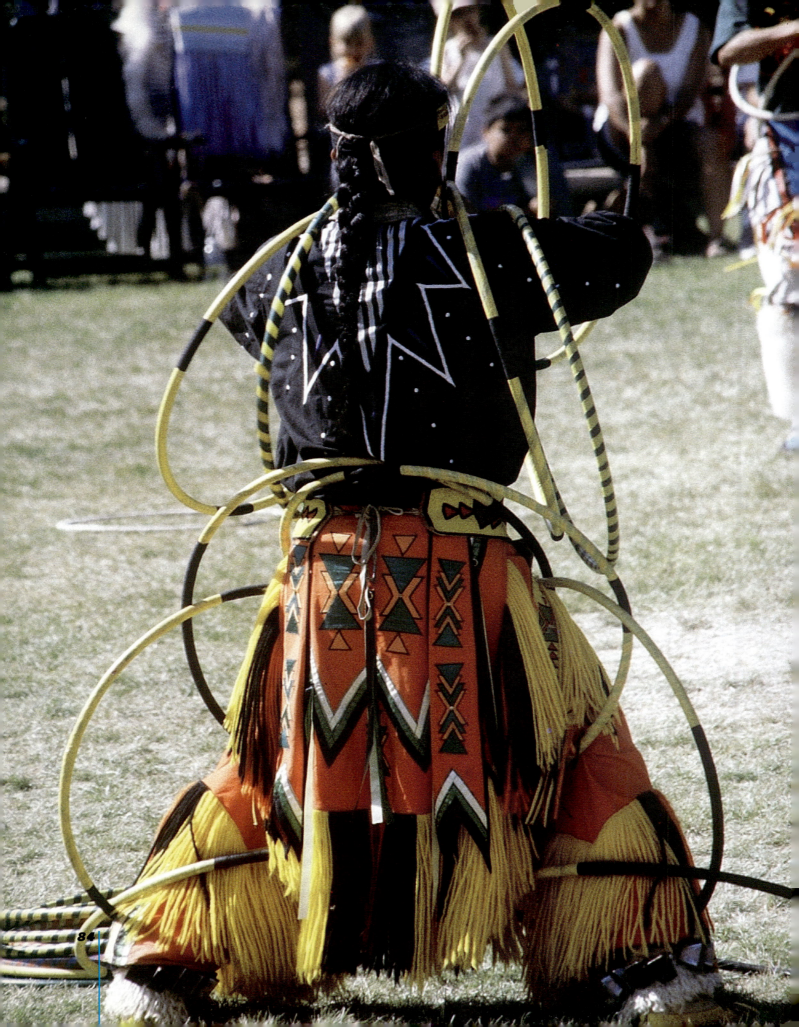

Chapter Eleven

The Hoop Dance

The Hoop Dance is visually spectacular. The dancer has to be able to juggle and manipulate the hoops while constantly moving in time to the drum. The hoop itself is an ancient symbol of the circle of life, unity, harmony and balance. Everyone is equal in a hoop, or circle.

The hoops were originally handmade from wood such as willow, then decorated with paint and sometimes fur. These wooden hoops would eventually dry out and break, and the dancers, ingenious as always, began to use more resilient materials such as rattan or hollow plastic tubing that could withstand the bending.

Dancers use anywhere from four to fifty-two hoops. Twenty-eight hoops are often used to represent the cycle of the moon. The hoops are individually made to suit the build of the dancer as they have to be able to move them very accurately and quickly over their bodies, arms and legs.

The regalia has to allow for the movement of hoops, so such items as bustles, aprons and roaches are not part of the Hoop Dancer's outfit. They tend to wear shirts decorated with ribbons as well as beaded headbands to keep their braided hair under control, out of the eyes and from interfering with the hoops. The headband and wide belt are beaded with designs created by the dancer; they may be geometric, floral or animals. Aprons similar to those worn by Grass Dancers, beaded moccasins, ankle and knee fringes complete the dance outfit. These outfits can be quite heavy, so fitness is important if they are to dance for an extended time and still look light and fresh on their feet.

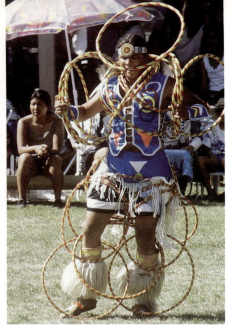

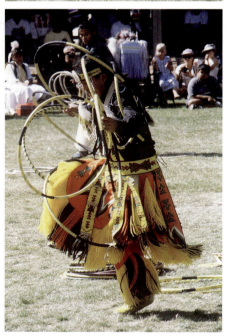

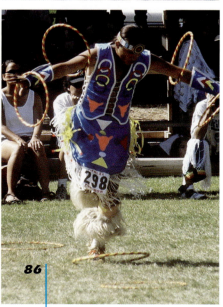

The origin of the Hoop Dance as a public dance is rather vague. It wasn't until some time in the 1940s that multiple hoops were used in public dance demonstrations. A member of the Jemez Pueblo Tribe, Tony Whitecloud, is credited with making the Hoop Dance popular. In 1990 Ralph and Dennis Zotigh began the now-famous Tony Whitecloud World Championship Dance Contest. There was an obvious challenge for the judges. How do you judge fairly dancers using only four hoops against those who use up to fifty-two hoops? Someone came up with the idea of using the scale used for the Olympics. The dance was divided into separate sections, such as speed, creativity, rhythm and precision. The points allocated went from one to ten. A dancer who used a high number of hoops could get a high creativity score while perhaps not scoring so high on speed. A dancer who used a lower number of hoops would score high in greater speed but not as much in creativity. A sense of fairness and balance was the outcome of this system of points.

Creativity in Hoop Dancing revolves around the designs made with the hoops. The hoops are lifted with toes and fingers while the dancer whirls around, moving nonstop in time with the drum. Suddenly, out of the juggling and rolling of the hoops, appears an eagle, a butterfly, a flower, the moon or a hoop of many hoops.

Each dancer has a story to tell about his movement designs. The eagle can represent our spirit, and we are told that we too can soar like the eagle; the sun and moon are like the new beginnings. We are all offered new choices in our lives every day. The hoop of many hoops is a circle of hoops connected into a ball or earth shape. It is held high above the dancer's head to represent all people of all colors connected in harmony. Some of the designs are quite difficult to recognize initially; the hoop within hoops is the easiest but you will soon begin to recognize all of them with practice.

The world championships are now held in Phoenix, Arizona. Hundreds of Hoop Dancers travel from all over North America to take part. Spectators come from every corner of the earth. You truly appreciate all the intricacies of the dance in one weekend after watching all these world-class creative athletes. Hoop Dancing is not

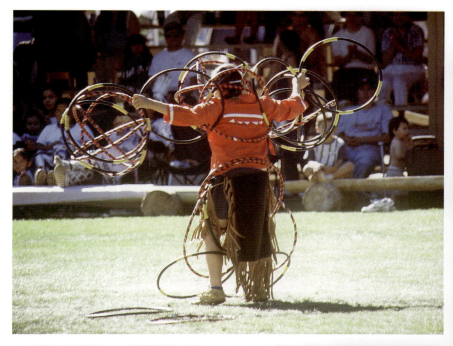
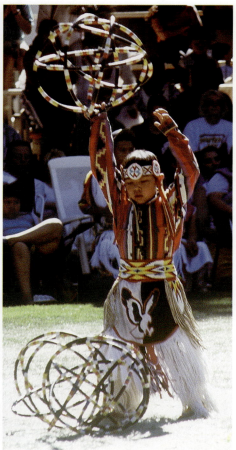
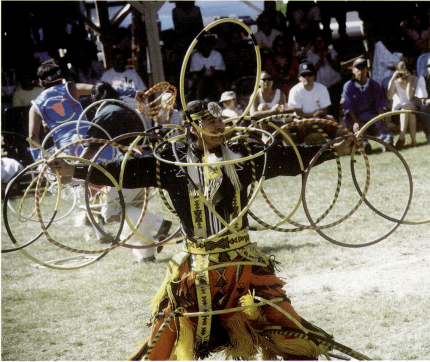
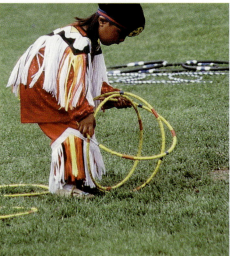

restricted to men, there are also women Hoop Dancers. The championships may be the place to see more of these pioneers. I have only seen one female dancer, years ago at the Chilliwack Powwow. She was poetry in motion and won the event. They are not very common at this time, but who knows how many future world-class women Hoop Dancers are out there practicing.

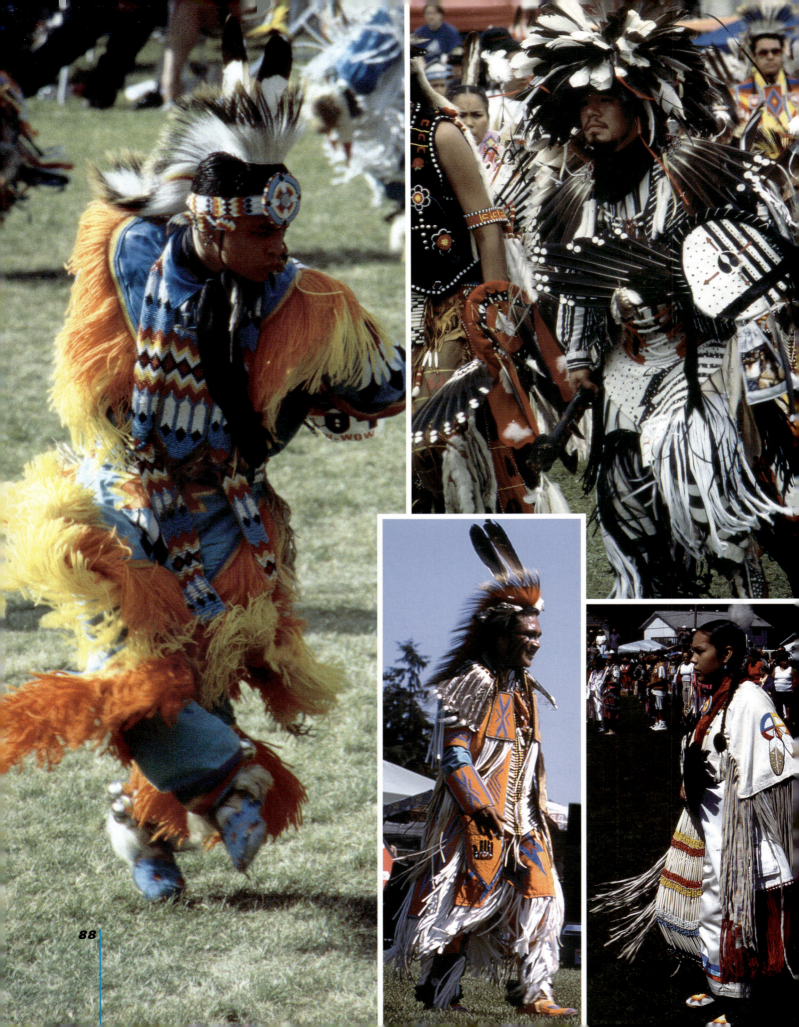

Chapter Twelve

The All-Around Competition

The All-Around Competition is not a very common event at pow-wows but it always seems to have a great turn out of competitors when it is on the program. Chilliwack held this event and it reminded me of a triathlon because of the variety of techniques and endurance needed. The competitors have to dance in every category each day of the powwow showing that they have all the proper moves and steps. A man would have to be able to perform Traditional, Grass and Fancy. A woman would have to do Traditional, Jingle and Fancy. Stamina is definitely a requirement for this event. The ability to be a quick change artist would also be an asset because dancers must wear the correct regalia for each dance. That is a lot of regalia to take care of and carry around—the dancers must have dozens of suitcases or a small trailer.

The judging for this event takes place throughout the powwow, the points being tallied after the last round. Judging is tough. The dancers have to be strong in each of the three styles to be in the running for the prizes.

It's fairly common to see the very young dancers trying out all the different dance styles over a period of time until they decide which they prefer. Over the years I've watched youngsters like Dakota try Fancy, Grass, Traditional and Hoop. I can still see him struggling with those hoops at Skwlax when they were as tall as he was. The last time I saw him do the Hoop Dance was in 1999. He was smooth! A future All-Around competitor? I wouldn't be surprised.

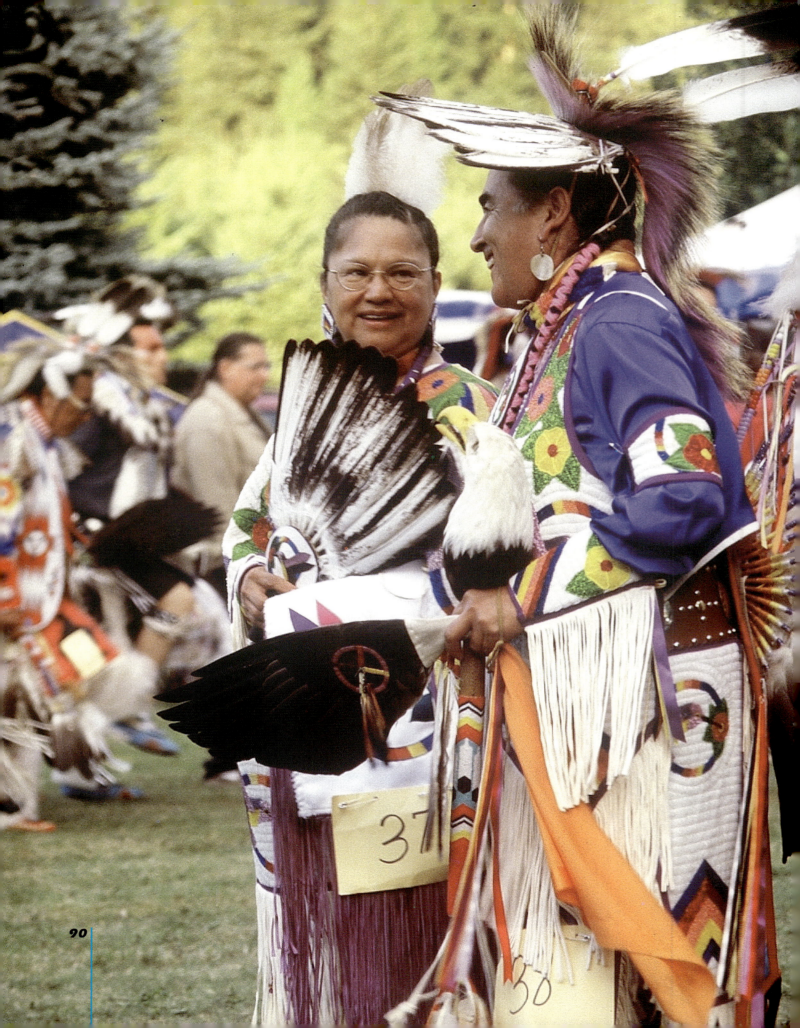

Chapter Thirteen

Social Dancing and Some New Dances

Social dances allow everyone at the powwow to participate, whether you are in regalia or street clothes, whether you are First Nations or not. Here, at last, is your chance to change from a spectator to a participant. Those tapping toes and nodding heads can burst out into full-scale dancing.

Intertribals are a chance for everyone to jump out of the stands and enter the arbor to dance with other spectators and dancers from every age and category. It gives people a chance to mix and chat as they dance around the arbor and it keeps the dancers' muscles warmed up for their competitions. Friends get together; parents carry their tiny tots and babies in their arms using the rhythm to rock them as they dance. One of my favorite photographs is that of a dancer wearing full bearskin carrying a baby in his arms. There are many intertribals at the powwows; try them.

The Round Dance is a circle dance where the dancers sidestep to the left while holding hands with the people next to them. It too is open to anyone who wishes to join in.

The Friendship Dance is a wonderful way to meet people. It is a form of the Round Dance but it is made up of two circles so that the people face each other. Both groups sidestep to the left so that as you move around you meet everyone, shake hands, smile and make eye contact with them. Sometimes the Whip Man or dancers will come up into the stands and encourage you to come and dance. It is hard to say no. Once you get over any shyness you suddenly discover you are having a ball. You are smiling and shaking hands a hun-

dred times over. This can be a long dance if the circles are large. Sometimes a mischievous drum will just keep on going and going. You may meet people twice or three times. When it's over you can collapse on the bleachers.

I was visiting Haida Gwaii, the Queen Charlotte Islands, several years ago for a Youth Leadership Conference. The closing ceremonies were held in the gymnasium in Old Masset and were hosted by the Haida people. We did a wonderful Friendship Dance involving about 300 people. There had to be two very large circles that caused us to go up and down the bleachers "thousands" of times so that we met everyone, not once but twice. We were all still smiling at the end when we collapsed. Need I (gasp) say more?

The Owl Dance, called the Two Step in the south, is the only dance for couples. Be prepared—this is a ladies' choice dance. Traditionally you may be expected to give the lady a gift if you refuse to dance with her. Refusal can be taken as disrespectful. It's much more fun to join in. Gloria explains that the couples dance side by side two-stepping around the circle. Couples who are friends hold hands in front, while couples who are partners have their arms around each other.

There are a number of fun dances have been introduced over the last few years. The Men's Fancy Shawl is a delight to watch. The men dancers, Traditional, Grass or Fancy, don one of the women's shawls and create an interesting version of the Fancy Shawl! The dancers are judged and prizes given amidst lots of cheers, laughter and wisecracks about the lack of light-footedness. Both dancers and audience enter into the spirit of this fun dance.

Team Dances are a huge favorite with both the audience and the dancers. There are teams of Jingle Dancers, Grass Dancers, Women's Traditional, Men's Traditional and Fancy Dancers. A team must have a minimum of three dancers and a maximum of six. Groups of dancers can be seen off behind the bleachers or amongst the trees practicing their choreography, making sure they move as a group, that their patterns work and they don't bump into each other. Precision rules supreme. The look of concentration can suddenly

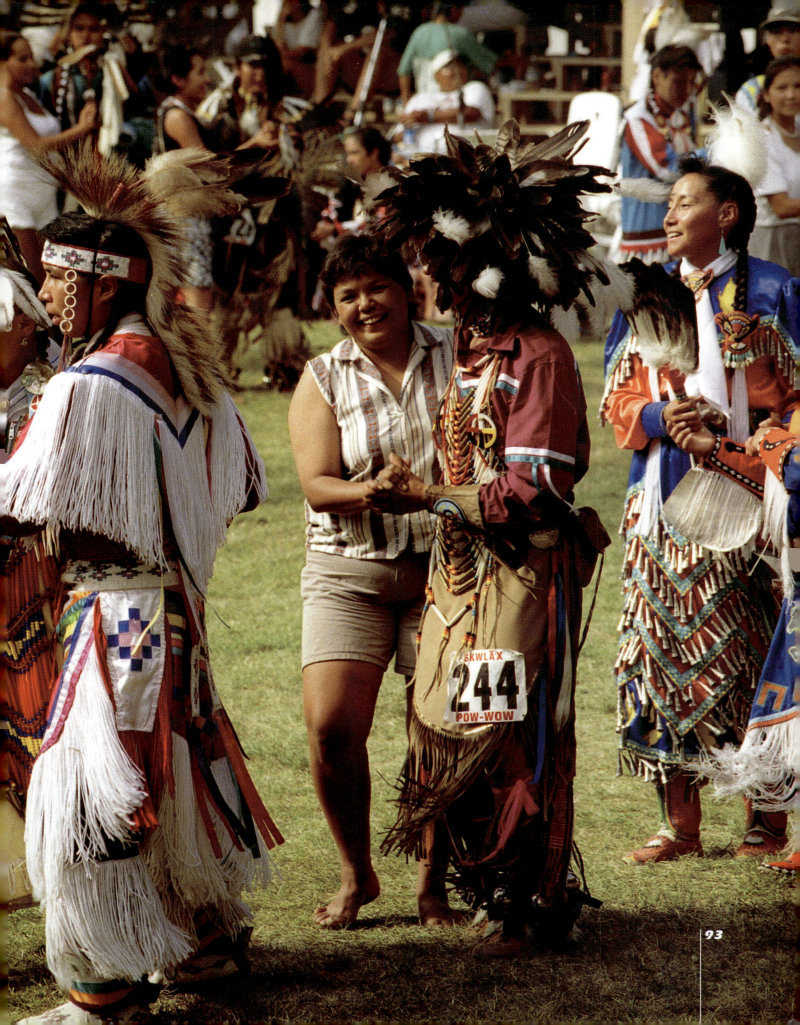

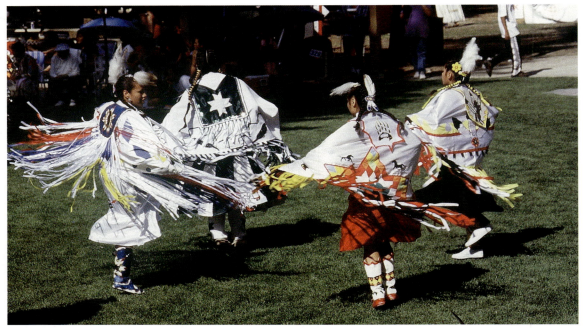

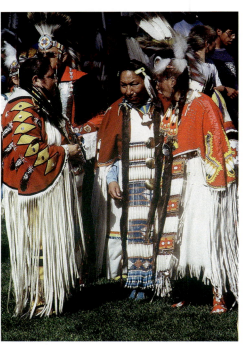

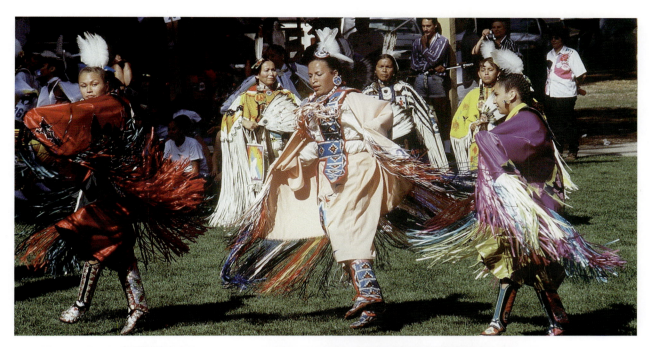

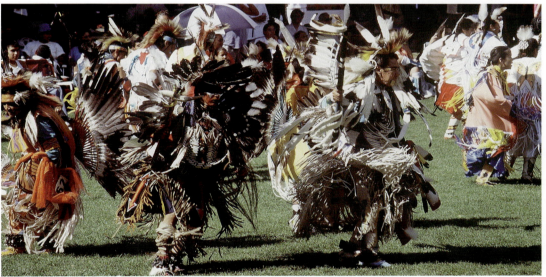

split into howls of laughter as they work out the routines. It is a wonderful spectator event because all the teams dance at the same time. You can watch the Men's Traditional team synchronizing hunting movements, while the Women's Traditional glide by serenely moving in concert and raising their fans. The Jingle, Grass and Fancy teams, however, whizz by, moving fast, flashing, leaping and whirling as one. As always, precision, being on the beat with the drum and finishing with the drum are the most important factors, but the choreography has to be considered too. The judges must have a tough time as they watch six different styles of dancing.

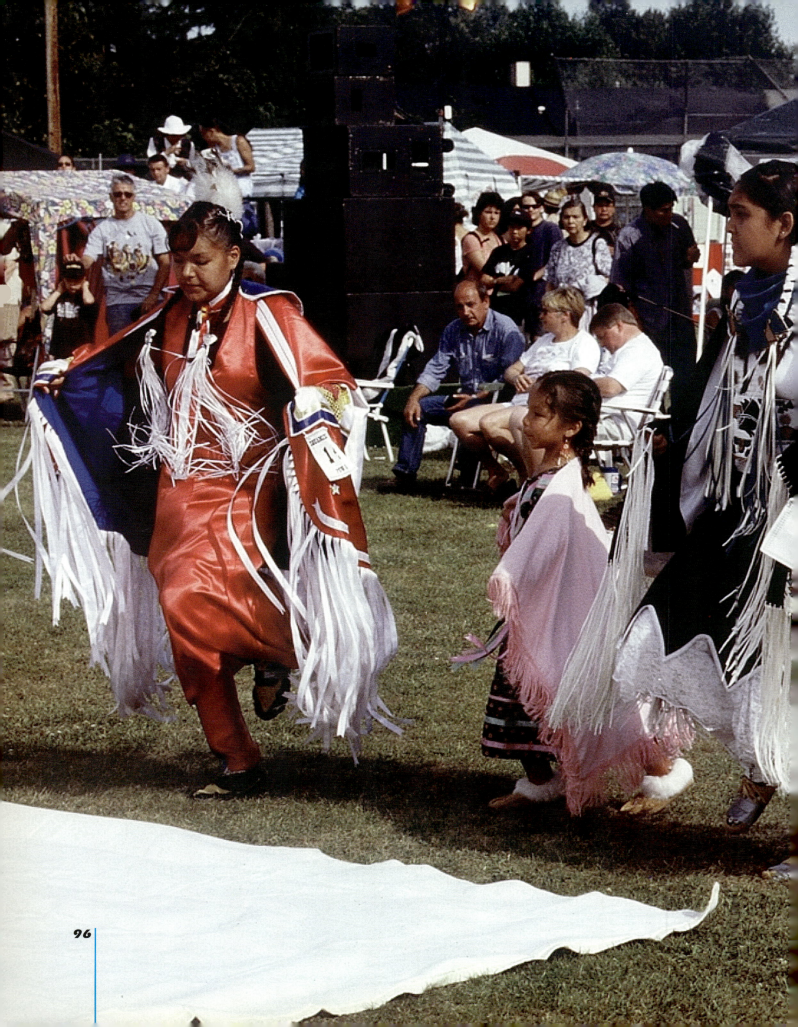

Chapter Fourteen

Special Ceremonies and Events

Traditional ways and values are honored and strengthened at powwow by special ceremonies and events, which are interspersed throughout the regular dance and drum contests. All of them may not be listed in the program, but they are announced by the master of ceremonies. He will call upon the Host Drum to sing and also give directions to spectators regarding the taking of photographs. Some ceremonies are sacred and photography is not allowed; it is extremely disrespectful to the ceremony and its participants to ignore these directions. Officials, dancers, singers or other spectators do not hesitate to reprimand anyone seen to be raising their camera.

The Coming Out Ceremony welcomes a new dancer into the dance arbor. The family of Jerri-Lynn Gonzalez had her coming out at the 2000 Squamish Nation Powwow. Bruce Butler, the M.C., called for the dancers who were to escort her as she danced for the first time in the arbor. Four blankets were placed on the ground representing the Four Directions and as they danced around the arbor followed by her family, Jerri-Lynn had to dance over each of them. Once she had completed one full circle and had begun the second, friends, dancers and spectators poured into the arbor to welcome her; after shaking her hand, giving her hugs and hundreds of smiles, they too joined in the parade of family and friends dancing behind her. At the beginning of the event she looked very nervous, but by the end she was smiling and proud. Another dancer had been welcomed into powwow.

Honor Songs are performed, usually by the Host Drum, for several important occasions. A song may be sung to honor an elder, a

97

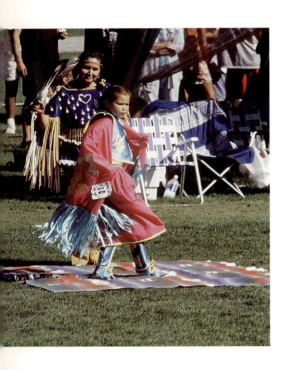

veteran or any person deserving recognition. Families who are returning to the dance arbor after being in mourning for a year are welcomed back by a special song. The M.C. will ask everyone to stand bareheaded, unless the man has an eagle feather in his hat, and show respect during an Honor Song.

Blanket Dances are not so much a ceremony as a fund raiser, but they reflect the generosity and support for each other in the powwow community. There will be an announcement when this dance is going to take place and explain the reason for asking for donations: a family may have suffered a tragedy, an excellent dancer is hoping to travel to the Gathering of Nations or a drum group needs help. The Princesses are called upon to carry the blanket as they dance around the arbor and the crowd is asked to throw what they can afford onto the blanket as it goes by. The money is then given to the family or person needing help. It is a good idea to carry change and small bills in your pocket for these dances; every powwow I've been to has had a blanket dance and it's a great gesture to participate by making a donation.

Dance and Drum Specials are arranged and funded by a family, or one person, who wishes to say thank you for an event in their life or to remember someone special who has died. These specials are contests, but they are separate from the regular powwow dance contests and they are judged separately. Gloria arranged for a Women's Traditional Special at Palm Springs when she was the Head Lady Dancer. She raised the prize money and had beautiful jackets made bearing her hummingbird design for the dancers who placed first, second and third. Ray Thunderchild held a Memorial Special for Cory Thunderchild at the Squamish powwow in the summer, 2000. The dance specials are always in a particular category and age group, for example Golden Age Men's Traditional. The Drum Specials are competitions for singing and drumming, again they are separate from the regular powwow drum competition and therefore are judged separately too.

Feather Pick-up Ceremony takes place when a dancer loses a feather while dancing. The arena director signals to the M.C. what

has happened and stays to protect the feather until the dancing stops. The M.C. announces to the audience that the Pick-up Ceremony is sacred, and that no photography or recording is allowed. Four veterans (warriors) are usually called to perform the ceremony while the Host Drum sings. The feather is said to symbolize a fallen warrior and must be treated respectfully by being picked up by warriors; the strict tradition is that only wounded warriors can pick up the feather, but this is not always possible. The feather is regarded as sacred and tradition says that anything sacred may only be picked up by the left hand; sometimes the feather is picked up with a fan. Once the feather has been picked up the drum stops and the warrior who has the feather will face east and give thanks to the Creator. He will then tell a true story of his own experience, and it will be used to teach a lesson and give a message to everyone, but especially to the dancer. The feather is finally returned to the dancer and he is reminded that care and respect should be taken with regalia—it is like our lives, special, unique, a prayer to the Creator. The dancer then thanks the warriors and the drum by giving what they can, tobacco, money or blankets. A lesson has been taught not only to the dancer but also to everyone present.

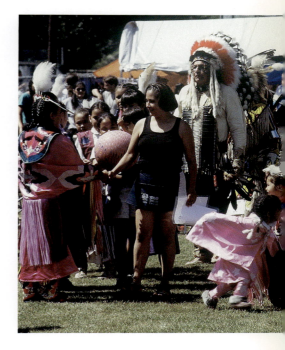

I remember the first time I saw this ceremony. Silence fell when it was announced there was a fallen feather. The M.C. reminded us that we must stand, bareheaded and that photography and recording were forbidden due to the sacred nature of the ceremony. Four veterans entered the circle and the drum and singers began the song. The dancers circled the feather, moving toward it then away again, almost like a sneak-up dance. Finally the feather was picked up and the warrior raised it to the sky and gave thanks to the Creator; at that very moment an eagle flew low and circled the arbor three times before leaving. You could hear a pin drop and a sigh rippled throughout the dancers and audience. The arrival of the eagle was taken to be a sign of forgiveness. I had goose bumps.

Some powwows do not stop the dancing for a pick-up ceremony. Sometimes after the circle has been blessed, the Grass Dancers have prepared the ground and the Grand Entry is over there will be one

pick-up ceremony with a representative feather. Nooksack Powwow uses this method by having a carved, painted hand, standing about three feet tall holding a carved feather. This one ceremony covers all dropped feathers throughout the powwow. Fallen feathers are still carefully picked up by a veteran but without everything stopping for the ceremony.

Whistle Carriers are very special people. The whistles, made of carved bone, metal or wood are sacred and are only played for special ceremonies. The Whistle Carrier may have been given his whistle by an elder or a parent because they have been deemed worthy of the honor; some may have earned their whistle by going through the Sun Dance ceremony. Each person will have his own story and may choose to share their story.

Sitting in the stands, you may suddenly notice that during an intertribal there is a crowd of dancers gathering and dancing on the spot around a drum and wonder what is going on. Go over and join the crowd and you will observe a sacred ceremony taking place. The Whistle Carrier may have been asked to whistle prayers to the Creator for someone who is ill or to say thank you for something good in their lives. Usually he will ask a drum to sing ahead of time and ask for a specific song; at other times he may just sit in with a drum group and decide on the spot that this is the drum he wants and he pays them with tobacco. The drum has to be ready to go with the right song.

The whistle does not play a tune. However, each sound is a prayer sent up to the Creator. He will blow his whistle four times to honor the four directions. At the Squamish Nation Powwow a few years ago, a Whistle Carrier had arranged to offer prayers and as he danced harder and harder the circle of dancers around him opened to allow three other Whistle Carriers to enter. This is a compliment for the drum but it means sixteen extra verses. On a hot day, actually any day, this is very hard work and they can damage their voices. Thoughtful observers will be seen to go and bring back bottles of water for them to help them ease their throats.

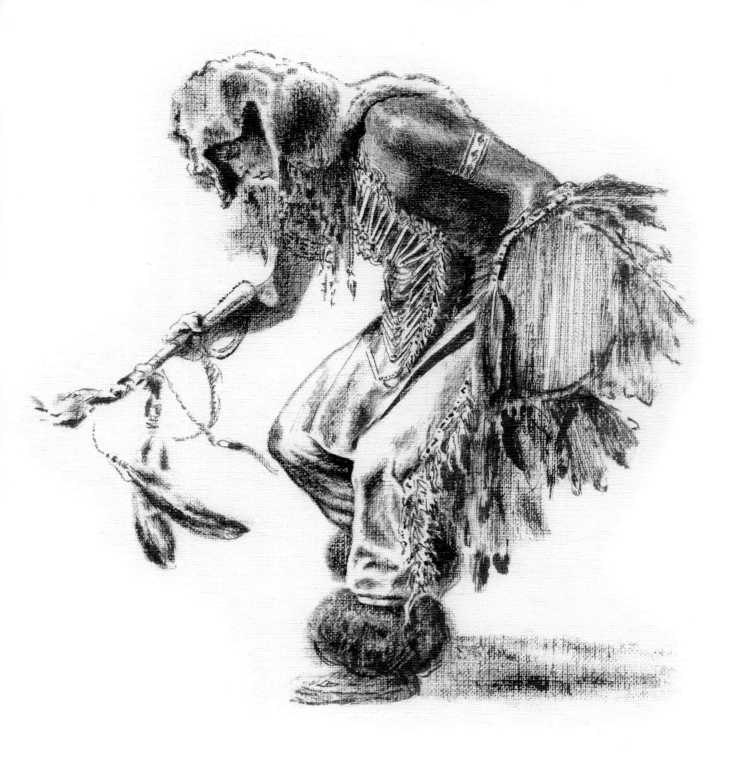

After the ceremony is over the Whistle Carrier will often take time to explain to the crowd the reason for the ceremony and recognize the person, or family, who had asked him to whistle. The ceremony is a direct communication to the Creator; therefore, no photographs are to be taken. Take heed.

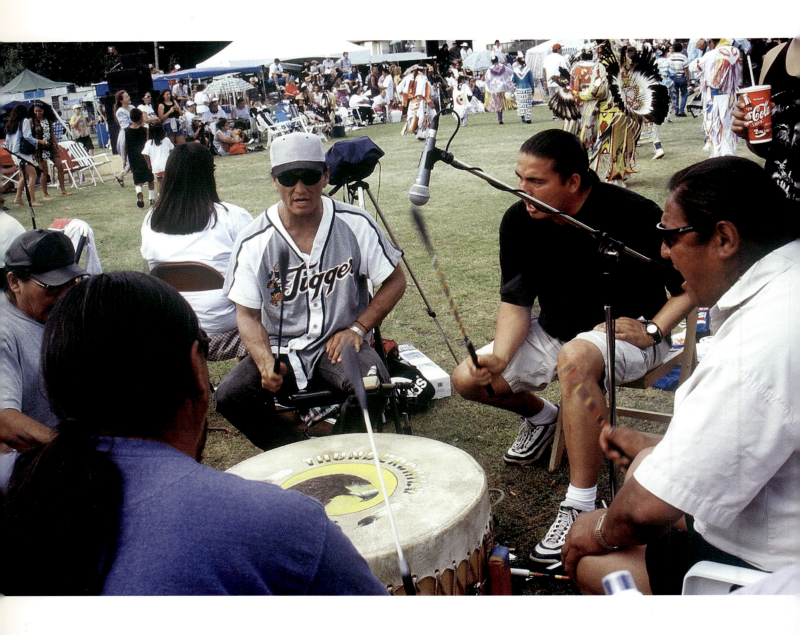

Chapter Fifteen

The Drum and Singers

The drum represents the heart of aboriginal people and their connection to Mother Earth. Its pulse reaches out to all of us and draws us into its rhythm whether we are dancers or spectators. It holds everything and everyone in balance. This balance is what the dancers strive for—total unison with the drum beat, with the rhythm.

Ray Thunderchild was taught the history of the drum by a group of ten elders when he was a child. Since then he has added to his knowledge by doing a lot of research on his own. He thinks that the big drums originally came into the southern states as a result of trading with the Natives of Mexico. The Apaches, Navajo and Oklahoma people adopted the big drum but they created their own songs and dances to connect to their own ancestral ways. According to Ray, the northern people were not very social. They were a warring society whose survival was determined by winning or losing the next battle. They had no use for a big drum; their traditional drum was a much smaller hand drum used for ceremonies such as the Sun Dance or for dances performed on other ceremonial occasions. The northern people were the last to be introduced to the powwows as other tribes from the south moved north bringing with them the larger drum, new dances and the new idea of contests. Gradually, one of the many changes wrought by time and outside influences was that their northern culture began to adopt more social activities, such as the dance and drum competitions of the powwow with groups who may have been their former enemies. This did not mean that the hand drum was discarded. It is still the traditional drum used for important ceremonies.

The two drums are both constructed from a wooden frame and a

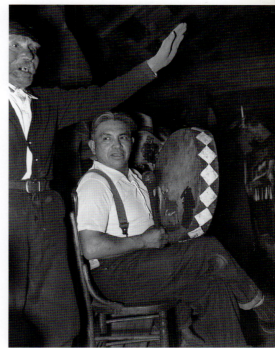

Photo: Seattle Post—Intelligencer Collection Museum of History & Industry.

hide covering and they both have their own special ceremonies and codes of conduct based on respect. The size creates a very different sound, however.

The powwow drum has a large base covered with moose, buffalo, elk, deer or cowhide and has to be treated with great respect. Thanks are given to the spirit of the animal who gave its skin and to the trees that gave the wood for the drum so that it would have its unique sound and connect all things to the Creator and the heartbeat of Mother Earth.

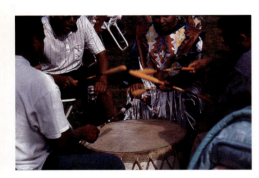

The singers are the other half of the drum. There can be up to ten singers with the drum, under the direction of a head singer; they work hard to blend their voices with the sound and rhythm of their drum and so create their own unique sound. Experienced powwow participants and spectators are able to recognize the singing groups such as Thunderchild, Thunderhouse and Arrows to Freedom by their sound alone.

It is an interesting experience to be at a powwow and suddenly realize that you seem to be hearing two very different kinds of drums. You are hearing the difference between the southern and the northern drums. The northern singers have quite a different sound from their neighbors in the south; they sing their songs at a much higher pitch. The songs are different too. If you listen carefully, you will notice that many of the southern powwow songs do not have lyrics; instead they use vocables, sounds, to create the melody. The northern songs use lyrics and sometimes a combination of lyrics and vocables. You will also notice that the southern drums usually end with five honor beats while the northern drums end with three. However, both groups have their fast trick songs, often referred to in the south as Ruffle Dances, to challenge the dancers. Only the dancers who have done their homework by listening to tapes of the drum groups know where or when these trick songs will stop and start. Next time you notice dancers, or their friends, clustering around the drum group with tape recorders you will know why. They take the tapes home and learn the songs off by heart and practice dancing so they know where the surprise stops and starts will come.

The drum is as important to the powwow as the dancers—proba-

bly the drummers would laugh and say they are more important, but dancer and drum are inseparable in powwow. Each needs the other.

Each powwow has a Host Drum—sometimes at the larger powwows there may be two—one Canadian and one American. Host Drums are chosen because of their reputation and their repertoire of songs; they have to have songs ready at any time for any occasion, such as Flag Songs, Honor Songs, tie breakers, Crow Hop or Chicken Songs. They may also be called to act as judges in the drum competition. It is rare that they leave the arbor because they are on call all day from the first drum roll call to the closing ceremony. The Host Drum is the only drum group that is paid; they are paid an honorarium, plus accommodation and travel costs. The amount may vary according to the size of the powwow and the funds available to the committee. They certainly have to work hard, their days are long and they need to take care of their voices. On a hot day you will see spectators or dancers go over to a drum and take them water to help them maintain their voices and their energy. It is also a great way to thank the drum and show your respect.

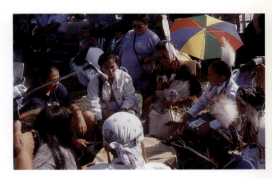

The other drum groups are like the dancers in that they have to register and pay a fee. They pay their own way to the powwow and compete for prize money. Freeland Jishie, who sings with Blackstone, one of the best southern drum groups, is on the road most of the time traveling from one powwow to the next. He enjoys the energy and tough competition of the big casino powwows, which have prizes of up to $20,000 for first place and $15,000 for second place. These big prizes draw the best groups from all over North America.

Thunderchild is a well-known and well-respected drum on the powwow circuit. Ray Thunderchild generously agreed to take time out of a busy schedule to share his drumming and singing experiences. Ray is a very good friend of Gloria and her family; they affectionately refer to him as Bigfoot! He stands more than six feet tall. But it's not his height that is impressive, it is his demeanor. He has that same quiet confidence and wisdom that Gloria and Keith carry with them. As he talked about his life, drumming and singing, his spirituality and pride in his culture blended together to reveal a man who cares deeply for his people. He spends a great deal of time working

with his Native brothers who are in the Kent Institution Prison, using drumming and singing to remind them of their cultural ways and beliefs they may have forgotten or never knew.

Ray tells us how his life has evolved and revolved around the drumming and singing since he was very young. "I was just a little boy when I first started. There were about fourteen of us, all within a five-year time span, who grew up together. We lived like gypsies in those days, traveling from farm to farm working to make money to live on and to travel to powwows. My family had its own little drum group, so there was singing all the time. My father and my grandfather were both singers, so they had a big collection of all kinds of songs. Wherever we camped, out would come the drum and singing practice would start. I would go to bed singing and wake up singing.

"I used to try and dance when I was little, but I had two left feet. I tried everything, but I embarrassed my father more than anything. At every little powwow I would dance, but I would fall flat on my ass. One day my dad said to me 'Look son, maybe you should try singing. Maybe that's what you need to do, not dancing.' Those were pretty serious words for him, so I said 'Sure.'

"All of us decided to join in and learn to sing. My two older brothers were first, then me, followed by my uncle and his family. Finally we had a family group of about twelve singers and we practiced at home and at grandfather's to develop our voices and learn all the songs. Gradually he gave us special responsibilities, like being the Staff Carrier or Drum Keeper and he started to teach us to be lead singers.

"I learned to sing in the old way by chanting, using only sounds not words. The old straight songs don't have words. I've had a lifetime of singing, so I know a lot of songs. I write songs too, but not songs with words. Songs and beat styles have changed over the years. The contemporary songs have words now, songs with specific lyrics. I will borrow some of those sometimes, with permission, because the younger singers want to sing them. I will only sing songs in our own language though, because it is too easy to mispronounce a word in Sioux or any other language and innocently insult a family or an elder. You also have to be sure you have permission to perform a song that does not belong to you. I was witness to an incident like this

once. A drummer had heard a song on tape, liked it and decided to learn it and sing it at one of the powwows. They were approached by an elder who asked them if they had permission to sing that song. They did not. It cost them their drum and all their equipment; they had to pay for their lack of respect. That was a very powerful lesson for that drum group and everyone else."

As Ray talked about the songs, Gloria and I began to talk about the structure of the songs with him. This has been one of the most difficult things for me to get a handle on or, to be more precise, to get my ear tuned into. We drew charts and diagrams; Keith joined in the discussion and Gloria added her information. I tried to keep track. This resulted in an attempt to draw a chart indicating a verbal description of the song structures, which can be found in the Appendix. It really helps to go over the information first and then listen to some songs on your powwow tapes and learn to hear the different parts.

We eventually got back on track as Ray shared how he was taught the special responsibilities and codes of conduct around the drum by his grandfather and father.

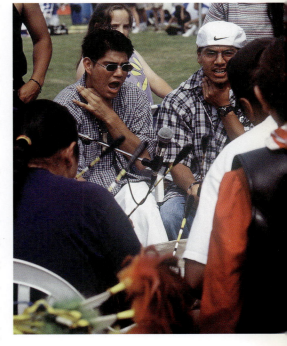

"My grandfather was the keeper of the family eagle staff, but when we went to powwows he would ask one of us to be responsible for it for the day. You were expected to guard it with your life; the staff was never to be left unattended. You could tie it to a pole behind the drum, but you always had to have it in your sight.

"The Drum Keeper looks after the drum. It's another one of those 'guard it with your life' responsibilities. I was asked to be the keeper by my grandfather and he expected me to know where it was at all times. I washed the drum and made a wrapper for it from a blanket to keep it clean. I kept that drum right at the foot of my bed; that drum had to be there for me to see when I wakened up in the morning for me to have a good day. Once my grandfather came into my room very early one morning before I awoke and took the drum. I didn't know where it was until I heard him singing and drumming over in his house. I went right over there, grabbed the drum and took it home. I was upset and angry with him for doing that and I told him he was disrespectful to me; he had asked me to be responsible for the

drum. His face turned red in front of his friends. I was about fourteen at the time and some of my family put me down for being disrespectful toward him, but I had to be that way. I had to let him know I took my job seriously and that he had trained me well as Drum Keeper.

"I made the drumsticks too; I used tape, leather or cloth to get the right sound we were looking for. You have to have good ear so that you can match the sound to your drum. I still do that now for my drum. I was also responsible for warming the drum so that its tone was true. I would take it over to the fire if it were a cold night, so that it would sound its best when we're singing.

"A new Drum Keeper has to go through a ceremony and be taught the songs that belong to that drum. There are four special songs that I sing, one for each direction; tobacco is offered and the drum is smudged. I don't do the whole ceremony every time I use the drum, but tobacco is offered every time we are going to practice or are ready to sing at a powwow. I usually designate someone to offer the tobacco; it gives more responsibility to the singers. Taking responsibility in the group is part of the training, so I will also ask someone to take care of my eagle staff. They have to watch that nothing happens to it during the powwow. Once a young kid came by and knocked the staff down to the ground and an elder came to me and asked 'Who is the keeper of the staff?' I looked around and saw that the keeper had left it and gone away to have a smoke. I called him back and told him that whatever he had in his pocket is what his lack of respect was worth. He lost his payday that day. I asked him to leave and he never sang with me again. He was careless; he did not show respect.

"I'm serious about this stuff. When I ask someone to look after the drum, I expect them to sit with it and to stand it up when it's not being used. I was taught that the drum is like our grandfathers and grandmothers, they take a rest every once in a while. Get 'em a chair; sit 'em down. The drum needs a rest too, so when it's standing on its side no one touches or uses it.

"The area around the drum has to be kept clean and free from garbage. I tell my singers to clean up. It is disrespectful to the drum and to ourselves to be sitting and singing in a mess. A well-disciplined

drum group never leaves the drum unattended, one person may go to get water or food, but there is always someone there to take care of the drum and staff.

"A drum group that wants to succeed works together and is disciplined. They practice the songs until they sound like they are connected together and to the drum. They carry out their tasks with respect; their spirits are in the right place.

"There are all women's drum groups in British Columbia and Alberta; these are the only places where I have come across women's drum groups. I'm not sure why there are no women's drums anywhere else. I see no problem with a drum group being all women. My dad had two women singing in his group back in the sixties. Two local ones that come to mind are Daughters of the Wind and Smoke Signal, I know there are more. They still have to learn all the same things and have the same respect for their drum as an all men's group. A drum definitely has its own spirit that's our connection to the Creator whether it is all women or all men. The spirit of the animal that gave up its life, the spirit of the wood that was felled and our spirit go together in what we always say is the three-way connection to the Creator.

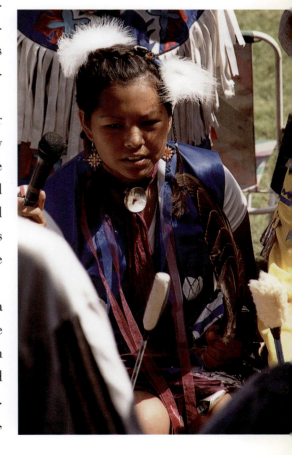

"The drum that I have now is a young drum; it's only about a year old. I was visiting a lady who had a drum ring, she was going to throw out because it was getting in her way. I told her I would take it if she didn't want it. I put it in my truck, took it home and asked a friend of mine to put on the two steer hides I happened to have. I now had my new drum, but it took me quite a while to get the drum sticks right. Once everything was ready, I had to have the ceremony for the drum; the one I told you about before.

"Then I had to build up my singers again. It's not easy to find a group of singers who fit together with the drum. A lot of them come to me because I'm a veteran at singing now and they know I will teach them well. I sit with them and listen to them sing. I'll sing lead and then I have to have that ear for each voice around the drum. Sometimes I already know the singer and I will ask them to sit down, offer them a cigarette and say 'Help me out' and they jump in.

"There's still a lot of work to do even after you have the singers.

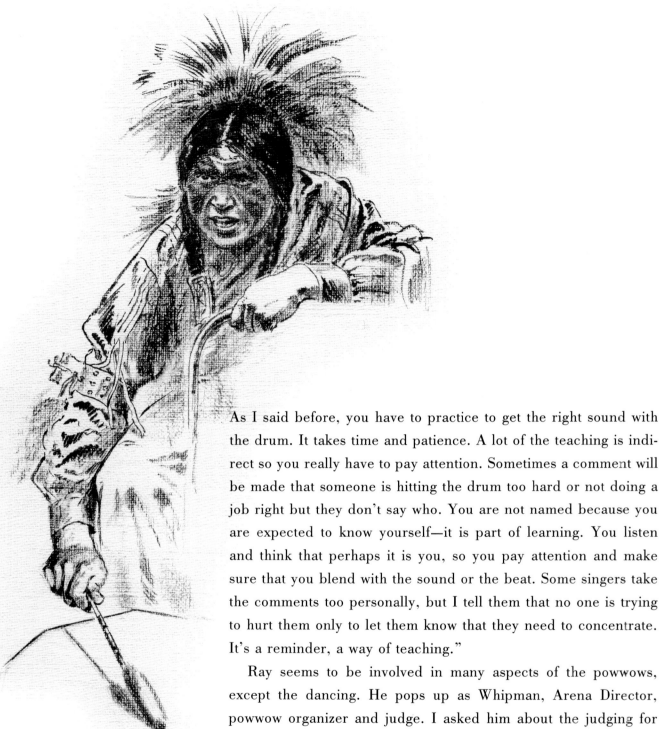

As I said before, you have to practice to get the right sound with the drum. It takes time and patience. A lot of the teaching is indirect so you really have to pay attention. Sometimes a comment will be made that someone is hitting the drum too hard or not doing a job right but they don't say who. You are not named because you are expected to know yourself—it is part of learning. You listen and think that perhaps it is you, so you pay attention and make sure that you blend with the sound or the beat. Some singers take the comments too personally, but I tell them that no one is trying to hurt them only to let them know that they need to concentrate. It's a reminder, a way of teaching."

Ray seems to be involved in many aspects of the powwows, except the dancing. He pops up as Whipman, Arena Director, powwow organizer and judge. I asked him about the judging for the drum competitions, he gave a huge sigh and said that judging is not his favorite job.

"You need ten eyes and about twenty ears. You really have to concentrate, try to stay focused. I listen for strong lead singers and then I focus on the rest, listening for strength and if they all sound

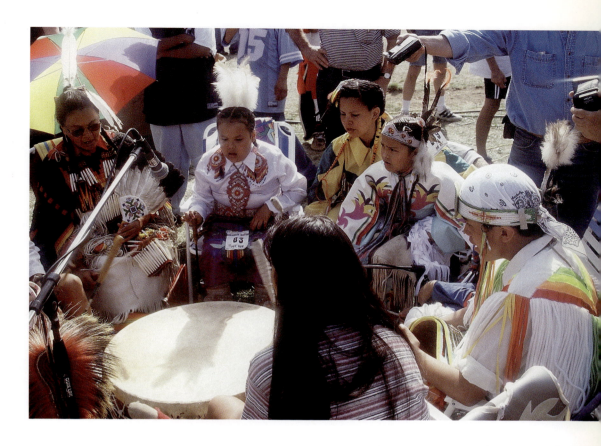

good together. They have to have a wide selection of songs ready and be able to sing an appropriate song at the right speed. The first night is usually a warm up, then by Saturday night the hype is rising. Sunday night however is a serious time; it's time for the finals. There are usually five or six judges; I like six because you often have a tie, which means there has to be a good sing-off on Sunday night. The air is electric when this happens as the drummers concentrate and sing their best songs. Then everyone waits for the final results to be announced. It's a really exciting finish to the powwow."

At the end of the interview with Ray, I felt he had taught me so much. He has an easy way of teaching. No wonder singers come to him and his prison groups enjoy their time with him. It was an honor to work with him.

Ray and Freeland Jishie outlined the judging criteria and drew up a sample judges sheet for you. They are in the Appendix. Have fun with them and with the song information too.

111

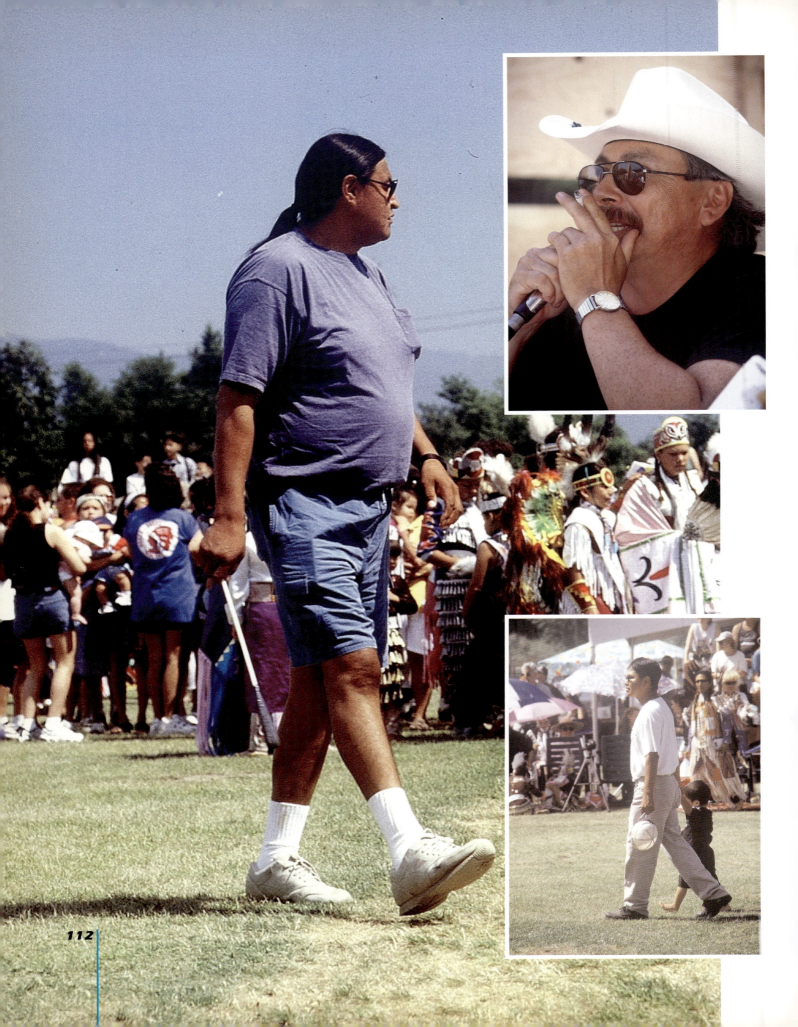

Chapter Sixteen

Master of Ceremonies, Arena Director and Whip Man—Three Movers and Shakers

You will very quickly notice these three men who keep the powwow moving along smoothly. They are the official movers and shakers—the Master of Ceremonies, the Arena Director and the Whip Man. They work together and are always visible and very busy. They must take a break sometime, but it must be in the middle of the night.

Gloria, Keith and other committee members are constantly on the watch for a good M.C., Arena Director and Whip Man as they attend other powwows; they watch and listen to see who would be a good person to invite to their powwow. They bring back their recommendations to the committee, who then make decisions and send out invitations. Sometimes a person is invited more than once because he does an excellent job. Bruce Butler is a good example of this; he has been invited three times to M.C. the Squamish Nation Powwow.

The M.C. is usually selected because of his knowledge of protocol, his respect for traditions and his sense of humor. He is the first person on site and the last to leave. His major task is to keep the program on time, so he is always on stage at the microphone making all the announcements and generally hustling everyone along, albeit with humor. The drum roll call before the powwow starts is coordinated between the M.C. and the Arena Director as it is important to know exactly who is present for the drum competition and before setting the drumming order for the dance competition. The M.C. also calls for the initial preparation of the arbor by the Grass Dancers and for the dancers to assemble for the Grand Entry when signaled to do so by the Arena Director.

The M.C. is the link between the committee he answers to, the

113

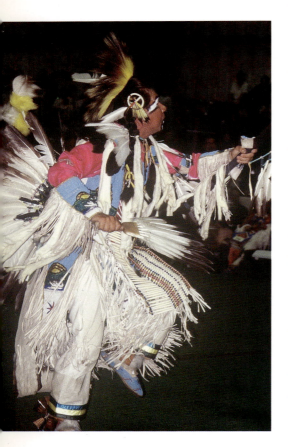

dancers, drummers, judges and the audience. He keeps everyone informed of what is happening and he also tries to teach the audience the etiquette of the powwow by telling spectators when they are expected to stand and when photography is not allowed. Special ceremonies may take place during the powwow, and at such times it is very important to listen to the M.C. You will sometimes see him leave the stage and go down into the arbor as he organizes a special, such as a Blanket Dance or Coming Out, when he needs Royalty to act as escorts or assistance with setting up a give-a-way. He also keeps an eye on the order of the drums and will call on the Host Drum for every special ceremony or when another song is needed in a dance category. An eagle eye is needed to stay on top of everything.

He calls for the start of the Grand Entry once he has the go ahead from the Arena Director and he gives a running commentary throughout the Grand Entry as he announces the Flags bearers, Eagle Staff bearer, Veterans, Royalty, the Host Drum and all the dance categories. The M.C. takes direction from the Arena Director as they work together to keep the events moving and people happy. No easy task!

Bruce Butler, an Ojibway from Chim-na-sing, south Georgia Bay, Ontario has been a singer for many years but in 1995 he was asked to be an M.C. for the first time. He quickly became a regular M.C. at powwows and is invited back to many of them. Bruce says, "You have to keep things moving. A sense of humor is important, as a major task is to keep everyone's spirits up, spectators, drummers and dancers. Dancers who feel good dance better; drummers and singers drum and sing better. The spectators have a good time. The energy from everyone combines to make it a great powwow for everyone. The points awarded to dancers for participation and being on time help to set a standard for our young people. Native people are a proud people. We have always been proud. We have always competed with each other—games, wrestling, running—competitive dance was a natural development."

The M.C. is the person you hear all the time, but the Arena Director is the person in charge of everything that happens inside the dance arbor. He gives direction to the M.C. who follows up with

announcements to make sure that whatever the A.D. needs is done, such as the preparation of the ground by the Grass Dancers and the blessing of the ground with sweet grass. He plays the major role in organizing the Grand Entry. He makes sure the Eagle Staff and the Flags are there; he chooses the carriers and receivers of the flags and lines up all the dancers. He checks that all the drum groups are present and will give tobacco to the drums and flag carriers. The program usually outlines the order of dance categories and some "specials," it is rare to see actual times assigned in print, but the Arena Director has to try to keep things moving smoothly. Things happen that can make this a challenge; a special such as a Men's Traditional may have so many competitors that he has to divide them into two groups and this immediately doubles the time needed, or the judges may need another song before completing their judging. Sometimes the crowd hoots and hollers and demands another song because the dancing was so good, a smart Arena Director accommodates this demand within limits.

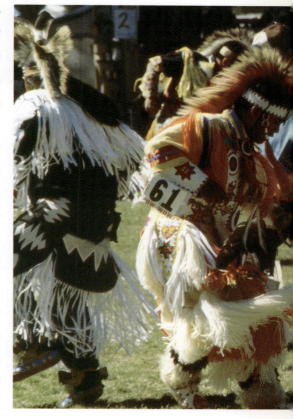

I recall the crowd at Skwlax hollering and banging on seats for more Hoop Dancing; the Arena Director allowed two more dances then, despite the continued hooting, he would allow no more. The dancers, needless to say, were relieved, as they were very tired by then. The M.C. followed up by thanking the crowd for their enthusiasm and calling for a round of applause for the tired dancers. Everyone stood up and clapped and cheered. A good closing.

The Arena Director has to be able to manage all of these wrinkles in the program. He also has to organize all Special Ceremonies such as giveaways and the honoring of a veteran or person. He must also protect a fallen feather and make sure that the proper ceremony is carried out. Everything is not predictable and he has to be able to make instant decisions.

Steve Hunt is a singer, a traditional dancer and Arena Director. Steve, like any other director, has his own style of doing things. He likes to have different Flag Bearers each day. "I arrange to get the Grass Dancers out to prepare and bless the ground before the Grand Entry. I choose the Flag Bearers. I usually give them tobacco and ask

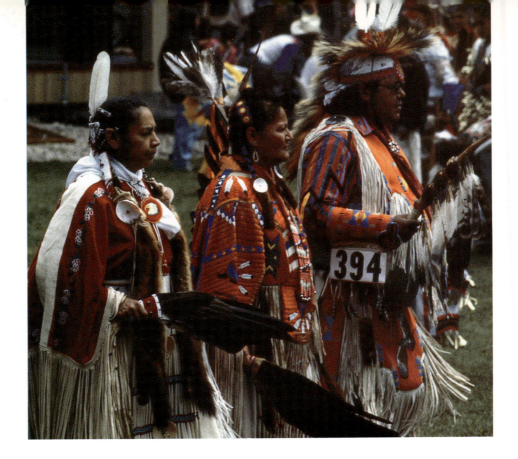

them if they would carry in the flags for that session. I ask an elder to come and say a prayer. Sometimes I choose all Traditional Dancers, but next time I will ask Fancy or Grass Dancers. If the powwow is celebrating youth, I will ask Youth Dancers from different categories. I also choose the judges. I try to make it fair by asking all kinds of people; sometimes I will ask people in the stands. Judging has to be seen to be fair, so I try to make sure I don't ask someone to be a judge who has a relative dancing in the same category.

"Being an Arena Director is hard because I have to deal with all my friends and they all want to have another song, but I have a time limit and I have to say no to them and sometimes they get mad at me. I also have to handle the crowd sometimes; kids run around and I have to go and tell them not to or ask their parents to keep them out of the arbor when there is a dance competition going on. It's like being a policeman sometimes.

"I have to make sure ceremonies like the Eagle Feather Pick-Up are carried out properly. Different powwows have different ways. The Blackfoot style, my way, is to offer tobacco to an elder to pick up the feather, there is no song to it or anything. Here it is done differently

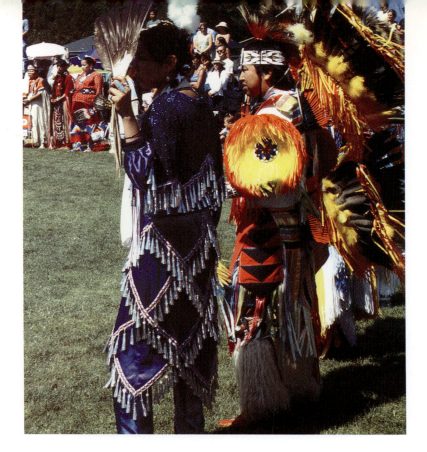

with veterans, song and drumming. I have to know which is the right way at the powwow."

The Whip Man takes care of the dance area; he makes sure it is clean and inspects the ground for holes, which may be dangerous to dancers and fills them in. He works closely with the Arena Director helping to keep everything moving, encouraging dancers to be out on the dance area and ready to go. This is a little different from that of the original Whip Man who held a position of great authority in the organization of the old Warrior Societies. In those days, the whip was actually used to make sure the men danced when they were supposed to. Today the whip is only waved toward the dancers as he verbally encourages them to join in the dancing. I, for one, am glad the role of the Whip Man has changed. I much prefer the diplomatic touch to the touch of the whip!

The M.C., Arena Director and Whip Man are on call all the time. Together they work to make the powwow a good experience for everyone. It is tough trying to keep everything moving without people feeling as though they are being hassled. Patience and humor are definitely high on the list of requirements for their jobs.

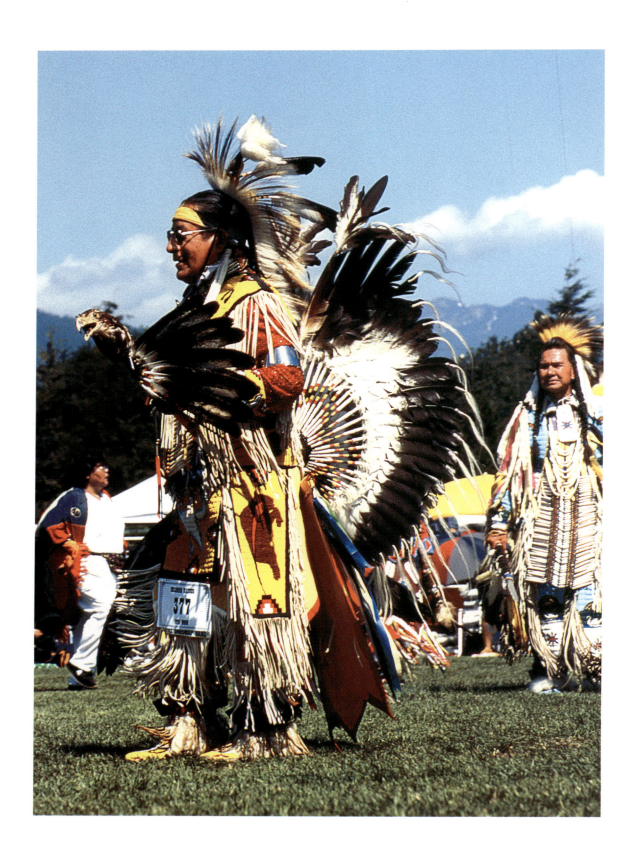

Chapter Seventeen

Positions of Great Honor: Head Dancers and Royalty

Head Dancers are chosen because they are respected as dancers and for their knowledge of protocol and traditions. They are people who act as good role models for other dancers, especially for youth.

Gloria has been asked to be Head Dancer several times. The last occasion was for the Palm Springs Powwow. It is a great honor to be asked to be a Head Dancer; however, the honor brings with it a great deal of responsibility.

"It's always exciting and, of course, I felt very honored to be asked to be Head Dancer. Then after a while I got really nervous about it, you know worried, like will I do a good job? You're always on call and you are the one the other dancers come to if they have concerns. Down in Palm Springs they would call the Head Lady and Head Man Dancers by name and ask us to start off the Intertribals, so we always had to be there, in full regalia, and the first ones up to dance. I don't know how many dances I did all weekend. My regalia is heavy, my cape weighs between thirty and forty pounds and my shoulders get sore from holding the weight of the beads and the buckskin fringes; if it's hot, you can't just take it off. I can't do anything else but dance; it's really hard even going to the bathroom.

"I try really hard to be a role model for the young people because they really watch everything we do and they're real copycats, you know. Whatever we do they're going to do. So I try to be respectful at all times, kind and smile at everyone and encourage them to dance. You can be tired but you don't show it, you just have to have a lot of strength, physical strength, and strong prayers for bringing in

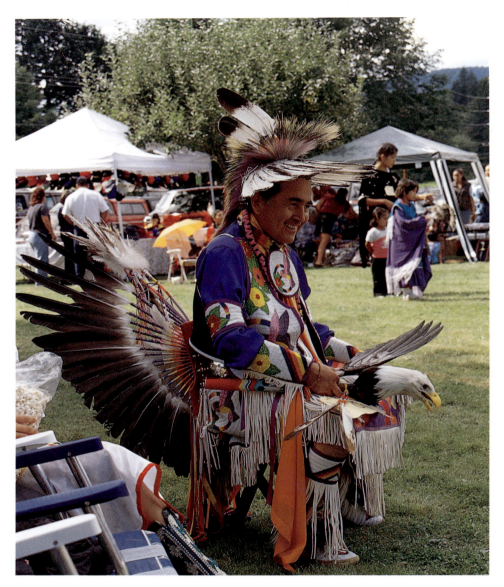

the dancers, asking that they'll be safe and that nothing will happen to them."

Steve Hunt has also been a Head Dancer. His experience at a small powwow still required the same amount of dedication and responsibility from him as a large one would. "I was asked to speak specifically to speak to the youth about leading a clean life, free from alcohol and drugs and to make sure they felt included in a positive way. It was a small powwow, so it was really personal. I had to be a role model and be out there dancing and at every Grand Entry. I encouraged dancers to take part in the Intertribals and the Social Dances. Dancers came up to me to tell me that they had one concern

and wanted me to say something to the committee. I took their concern to the committee and everything was always sorted out. I was happy because I was able to help solve their problem."

Every Head Dancer has his or her own personal style when acting as a spokesperson and problem solver. Respect is the underlying foundation for everything they do. Their days are long, their feet are feeling frayed around the edges from dancing for hours and hours and their bodies are tired from carrying heavy regalia all day, sometimes in very high temperatures. Regardless of the circumstances, you will see a person with a calm, smiling, patient, respectful demeanor moving gracefully around the arbor talking to young and old encouraging them and answering questions. You will see no indication in public of discomfort of aching shoulders or sore feet.

Royalty—Princess Pageant

The Princess Pageant is a part of almost every powwow. The contestants in these competitions do not enter them lightly. They have to decide well in advance if they are willing to take on the very responsible role of being the representative of their powwow for a whole year as it will require a great deal of personal dedication from the person who is chosen to be a Princess.

Usually there are two categories of Princess: Junior aged from nine to twelve years old and Senior aged from thirteen to sixteen years old. Sometimes a committee will also include Tiny Tot and Young Brave categories. Selecting a Princess requires the judges to look for the best person to represent their powwow using a set of criteria they have developed that outlines the special qualities they are seeking. The candidates do have to meet certain requirements before they can be considered. They must be of Native ancestry, single and be drug and alcohol free. They must also be dancers so that they can participate in the powwows they will attend. Knowledge of and respect for protocol are essential if the Princess is to be ready for any of the special events. Kindness and respect toward others, especially the elders, are key qualities the judges must look for in a Princess. Finally, but of equal importance, they must be ready and willing to help at any time throughout the powwows.

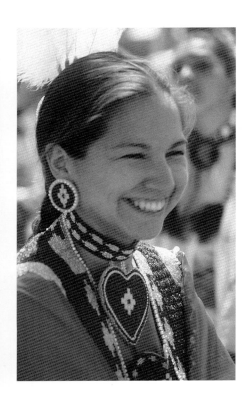

The girls work hard to prepare for the competition by making and designing their own dresses. The Squamish Nation candidates design and make their own velvet paddle dresses trimmed with ribbons. They have to be able to represent their powwow committee and their nation with confidence and to speak clearly in front of many strangers. These are not easy tasks, and therefore they are helped by volunteers who work with them for many hours as they practice public speaking and moving confidently in front of an audience.

Committee members usually observe the Princess candidates' demeanor in everyday settings during the preparation time before the actual judging. They want to be sure that their Princess can carry herself well at all times. Judging and scoring of each candidate is based on dress design, shawl design, artistic craft, hand and body movements, clarity of speech and their autobiographical speech. Different committees may have their own variations on the judging criteria: for example. the design of a paddle dress is specific to the Squamish Nation Powwow as this dress is their traditional regalia.

Everyone who takes part in this event is a winner. They develop a sense of pride and self-confidence as a result of the training they receive from their volunteer coaches and from each other. It is a great honor to be chosen as a Powwow Princess but it is not a role to be taken lightly as it requires an incredible amount of personal commitment and time from the Princess and her family. The Princess needs to have regalia to be a dancer and to travel. The young women and girls are on the road almost every weekend and need to be "escorted," especially the Junior Princesses. Family is expected to travel with their daughters or to make arrangements for them to be with someone they trust.

Kanani tells, with pleasure, how she enjoyed her year and her role as a Powwow Princess. "The hardest thing for me to do was to speak in public. Standing in the arbor surrounded by hundreds and hundreds of spectators, dancers and elders all looking at me was scary at first. Now I'm used to it. It was a lot of hard work, I had to be available at all times as I could be called on unexpectedly by the Master of Ceremonies to help an elder or assist at a special event. Throughout the Powwow I took care of the elders, making sure they

were comfortable or bringing them water when it was very hot. As the official hostess representing the Squamish Nation Powwow I wanted to make sure that people were comfortable and to help them the best that I could.

"I took part in all of the Grand Entries wearing my crown and sash; the only times I didn't wear my Princess crown and sash was when I competed in my dance categories. During the Grand Entries at our own powwow I lead in all the visiting Royalty from other powwows and also made sure that they were looked after. I took part in all the Specials; for example I had to be part of a Coming Out Special, the ceremony for a new dancer. Several of the Princesses had to escort the dancer around for her first time, during the second time around other dancers and spectators join in and come out to welcome the dancer. Blanket Dances also use the Princesses to carry the blanket around the arbor. The dance may be to raise money for a family in need or to help a dancer or drum group who has traveled a long way. People throw money onto the blanket as we move around and the money is collected and given to the family. Sometimes I helped at Give-Aways by helping the family set up and organize the gifts they were giving away. I also helped the organizers to raise funds by helping to sell programs, the 50-50 and raffle tickets. It was always very busy at the powwows; I really enjoyed it though.

"I got to meet so many people during my year as Princess because I had to travel to many other powwows. The Princesses and other Royalty got to know each other really well because we kept meeting and helping each other at all the powwows. Visiting Royalty share a lot of the same tasks and responsibilities as the "home" Princess such as taking part in all the Grand Entries and bringing greetings from their committees and they, too, have to be on call for helping with special events at every powwow they attend.

"The most important thing I had to remember was that I was at the powwows not as Kanani, but as Royalty and that I had to represent the Squamish Nation Powwow the very best that I could.

I felt sad when my year was over; I had traveled all over and met many wonderful people. I learnt so much about myself and the best part of all was I had become more self confident."

Chapter Eighteen

Judging Is Not an Easy Task

"Are there rules for judging?" "What are the judges looking for?" "The dancers all look great to me!"

These comments and questions are heard many times at powwows as the audience watches the judges making notes and conferring after a contest. I recall feeling frustrated by my own lack of understanding and asking myself the same questions at the first powwows I went to. I was quite shy in those days and hesitated to ask questions of a stranger, even if they might know the answers. Those days are long gone; now I ask questions all the time.

I discovered that people like to share what they know at the powwows. Armed with this knowledge I now ask Keith, Gloria, Steve, Florence or Karen and wander up to unsuspecting judges at Mission, Skwlax, Kamloops, Trout Lake, Fort Langley and Chilliwack powwows and politely ask them if they could explain what they look for and how they decide on the points. They always take the time to answer my questions.

It seems there are some specific rules and some general guidelines. The beauty of this is it allows for individual tastes in style and personal reactions to how the dancers "touch" the judge either by a sense of spirituality, grace, pride and being one with the drum and the Creator. The Fancy Dancers may impress the judges with their footwork, regalia and oneness with the music; the Grass and Jingle Dancers may dazzle the judge with flowing movements and the rhythm of the jingles. The gracefulness or animal and warlike actions of the Traditional Dancers can have a strong influence on the judging, too. All of these decisions are made from a very individual point

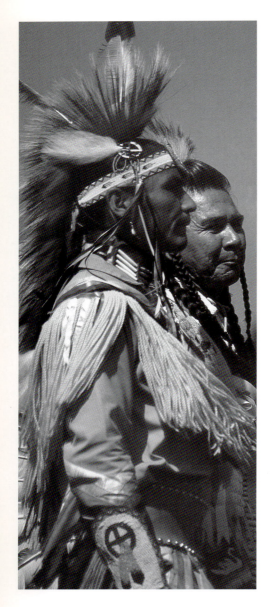

of view that is kept in balance by specific guidelines that have to be applied by all judges.

The most important factor in all the dance categories is the dancers' timing—the dancers must keep time with the drum and finish on the last beat with the drum. Judges may be directed to look for various movements in the different categories and to be observant of the regalia. Some powwows have criteria for regalia, for example Skwlax requires Fancy Dancers to have a minimum of four bells, and others will not allow running shoes or sunglasses, unless they are prescription. Ignoring these rules causes a dancer to lose points in their competition. The judges will automatically disqualify a dancer who loses any part of their regalia during a contest, unless the dancer withdraws. The loss of an eagle feather is very serious and is described in the Special Ceremonies chapter.

Judging is a personal affair, even when all the rules are taken into consideration and balance is maintained. It can't be too personal though. Judges are expected to excuse themselves from judging when a relative is dancing, if they do not do so the dancer is automatically disqualified. It is important that the judging is seen to be fair.

Judges are usually selected because of their knowledge of the dance. The big powwows that offer large prizes follow this protocol. The small powwows may not, instead they often choose to be more informal and ask all kinds of people, dancers, youth and spectators to participate in the judging. The randomness of this style of choosing judges provides its own kind of balance and fairness. Steve Hunt selected judges at the Squamish Nation Powwow when he was the Arena Director by asking dancers and people of all ages from the stands to judge. He felt that it was a great way to make people feel welcome and respected. Not everyone accepted the invitation, but they felt really good about being asked, so he still achieved his goal.

I was at the 1999 Fort Langley Powwow standing watching and thoroughly enjoying this small intimate event when suddenly Rena appeared in front of me and asked me to judge. I froze. I was stunned and then began to babble "B...b...but I don't know what to do, what to look for...." It was not one of my better moments. She smiled at

me and explained how it was okay and I would be fine! I have to admit I didn't have the courage to do it; but ask me now!

Inevitably young dancers are keen to improvise by adding new steps and moves into their dances as has happened throughout the history of dance. Some judges are concerned about preserving the traditional form of a dance when they see styles from different dances being combined; for example, they may see a Jingle Dancer including moves from the Grass or Fancy Dance into her choreography. These judges are very strict and will penalize the dancer who does not remain true to the specific traditional form. It is important that dancers be aware of the preferences and respect the beliefs of these judges when competing before them by remaining true to the traditional style of their dance, especially in the large powwows with significant prize money.

Judging is definitely not an easy task.

Despite that, Gloria and I thought you might enjoy having a judges' score sheet for yourselves so that you could try your hand at being a dance judge. Gloria has provided a score sheet she uses at the Squamish Nation Powwow in the Appendix. It includes the judging criteria and guidelines that seem to be consistent at all of the powwows. You could try it by yourself or do it with a friend or, if you are shy, quietly make notes without anyone seeing what you are doing. Who knows, you may be asked to be a judge and you'll be ready.

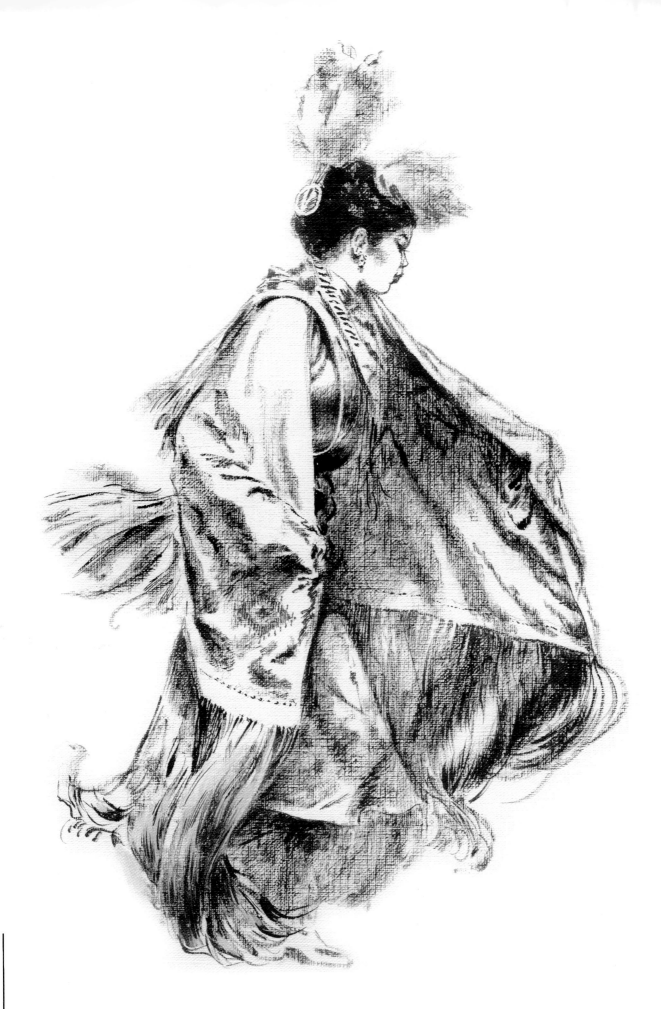

Chapter Nineteen

The Judging is Over—Now What?

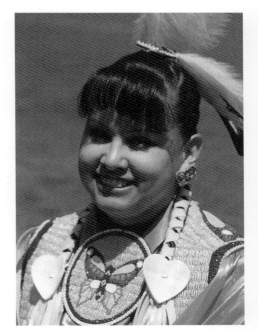

Once the judges hand their ballots in someone has the task of actually finding out who won. I thought that would be a fairly simple task, but based on past experience I decided I should check that perception out. I met with Riannon, knowing that she was heavily involved with this part of the powwow and asked her to tell me how it was done. We sat together one evening at her mom's table and she explained the whole system to me. "It's all about accumulating points," she said. "It's not simple; in fact it is quite complicated."

Riannon explained how she works with a team of volunteers who make sure that everything is in place and ready to go well before the first day of the powwow. "Lots of things are taken for granted; they seem so obvious that no one questions whether or not they will be there. Imagine the chaos if there were no numbers ready for the dancers or ballot sheets for the judges.

"Orene Brown makes all the numbers, prepares the ballots and the tabulation books by category and obtains the identification bracelets which the dancers and drums use as passes to leave and enter the powwow grounds. She makes sure that all the small details are seen to, those essentials of organisation—pins, pens, clipboards, tape and the ever-versatile duct tape. These details all have to be attended to well before the powwow.

"The rest of the team, Sarah Baker, Colleen Guss, Elizabeth Nahanee, Kanani and myself, also have to prepare ahead of time. We each take responsibility for tabulating a dance category throughout the competition and make sure that we have our tabulation books, plus all the numbers and bracelets for the dancers ready for regis-

tration. We also attach the ballots, by category, to the judges' clipboards while at the same time preparing for the possibility of a tie.

Friday morning arrives and we are down at the grounds setting up our table and double- checking everything—just in case. Eventually the dancers begin to arrive, all at once of course, and the registration process kicks into high gear.

"Dancers report to the tabulator responsible for their category and are given their numbers, pins and bracelet while their names are entered into the book against their number. This is the moment when the time spent setting up the books ahead of time really pays off. The recording of all the competitors' names is only one part of the registration; however, we also have to be building a separate list of all the visiting Royalty, by name, title and tribe. The Master of Ceremonies has to have this completed list before the start of the Grand Entry so that he can announce each one and call them forward to be introduced to the audience.

"After the dancers are registered, numbers are pinned on and the Royalty have all donned their crowns we are ready for action. It begins immediately, even before the Grand Entry. The Drum Song is announced and the Grass Dancers are called to prepare the circle, as they dance their numbers are recorded by judges for participation points. These are the first points recorded at the powwow.

"Participation points are very important; they can cause a dancer who has the most dance points to lose their competition." (This is where "simple" goes out of the window. Riannon was very patient with me over this whole concept of participation points; my excuse was, and still is, I was tired after a long day at work.)

"Dancers are encouraged to take part and be involved throughout the powwow. The Head Dancers and the Whip Man encourage them to dance for Intertribals and Grand Entries as they move around the circle; the powwow organizers encourage them by awarding participation points.

"Grand Entry Points are awarded on a decreasing scale. There are four Grand Entries; the first one is on Friday evening and is worth 100 points because the committee would like everyone to be there from the beginning. The second, on Saturday, is worth 75 points,

while the third one, also on Saturday, is worth 50; the last one on Sunday can add 25 points. A dancer who takes part in every Grand Entry will have won 250 points, which will be added to any contesting points won during competition. That's a lot of points.

"Exhibition Points are another way of accumulating points; these are used for adults only because they usually contest at night. Early in the afternoon, sometimes immediately following the Grand Entry, the M.C. will call for all categories of adult women, or all men, to dance together without being judged. After the dance is over, they are asked to line up while their numbers are recorded for 20 points, they are then excused until the evening, when they return for the Grand Entry or their dance category.

"Spot Check Points are always a surprise. The M.C. will suddenly call during an Intertribal for all dancers to hold their places while a spot check is taken. The drum stops and judges walk around the circle recording numbers and awarding each person 10 points, while others make sure nobody who was not dancing slips into the circle.

"All these points come to us and we enter the points against the dancers' numbers; the Exhibition Points are fun to do as they are cross category and all come in at once. Contest Points are for the competitive dancing. You already know how the different categories are judged. The judges complete their ballots by recording, in order, the numbers of the dancers, and then send them to us, we enter 100 points for a first place, 75 for second and 50 for third. Each dancer competes twice and care must be taken to cross-check the results, including all points, for a tie. If one of us spots a tie, we must inform the M.C. immediately; he asks the Arena Director when he would like it to take place. Sometimes he will say he would like it right away and sometimes later. It is his choice. Only one or two judges are used for a tiebreaker and they must choose only one dancer, their winner; again the ballots have to go to the tabulator for that category, who very quickly passes the winning name on to the M.C.

"We have to be on site at all times, until the last winner is announced at the end of the last day. We try to spell each other off for bathroom breaks and getting something to eat and drink. These breaks are short because there are always results coming in and

although the pace is fast, accuracy is crucial. Contest, Participation, Exhibition and Spot Check Points have to be constantly checked and cross-checked. It is really important to keep the ballots, in case of a dispute. Sometimes we have to go over all their points with a dancer so they can see for themselves."

Did I mention diplomacy was a prerequisite for this long, detailed oriented job? Riannon walked me through some examples to illustrate how participation can affect the final results for a dancer. I have included them in the Appendix for your perusal. Enjoy working your way through the categories of points. You are ready to jump in and help anytime now.

Chapter Twenty

Go My Son

Anonymous: Song taught to Chan Es7a7awts *students.*

Go my son

Go and climb the ladder

Go my son

Go and earn your feather

Go my son

Make your people proud of you

Work my son

Get an education

Work my son

Learn a good vocation

And climb my son

Go and take a lofty view

From on the ladder of an education

You can see to help your Indian Nation

And reach my son

Lift your people up with you.

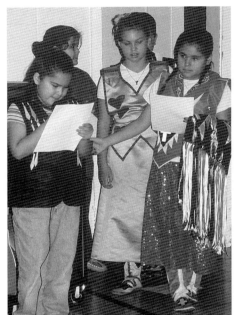
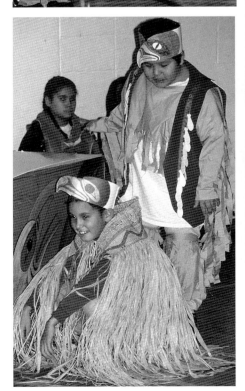
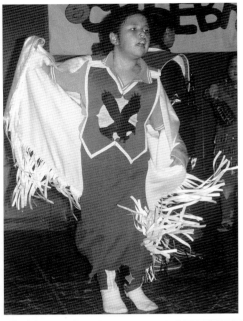
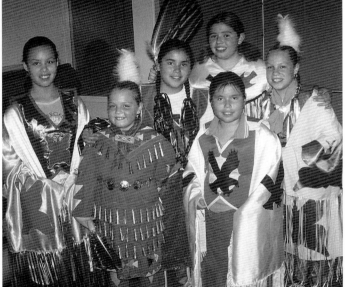

Chapter Twenty-one

It Begins Here

Chan Es7a7awts—Yes, I Can Do It. The powwow dancers, drummers and singers all seem to possess a quiet confidence. The high energy Fancy, Grass and Jingle Dancers seem to move with the pride and confidence of youth—eyes alert, their bodies supple. The Golden Agers, or elders, move with stately grace, their eyes reflecting the pride, wisdom and the journey of their lives. How did they acquire this tangible confidence, this self-respect? Perhaps someone, or some event, somewhere along their life's journey helped to build confidence and give inner strength. I doubt that we will ever know all the stories behind those eyes.

However, I do know of one person who plays a powerful role in helping youngsters discover their self-respect—Gloria. "I was taught by the elders when I was very young. I would go and sit quietly and listen to them tell the stories of our culture, our people. I remember them telling me one day 'We are not going to be here forever and you will teach our children about our people, our history, tell them our stories and teach them our songs.' I thought to myself, 'No Way.' I could never talk to groups of people; I was really quiet. I remember praying and praying for so long to the Creator, asking for someone to come and teach our children about our culture. I just never thought it would be me.

"Well, here I am teaching a cultural program called *Chan Es7a7awts*—Yes, I can do it—at the *Esla7han* Learning Centre in North Vancouver. Mrs. Molinsky, the principal of our daughters' elementary school, really encouraged me to work with our Native students. So I developed a pilot program, Sea and Sand, which looked at everything that lived in the sea and on the beach. My brother, Roy

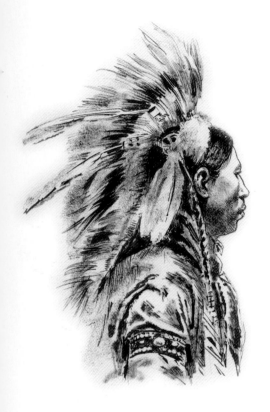

Baker, is a language teacher and he translated everything into our Squamish language. I taught them the Paddle Song, which our ancestors used to sing when they traveled in their sea-going canoes. Keith, my husband, made three big cardboard canoes, with seats and sets of paddles for us to use in a concert at the school. The kids were so excited and proud. We performed the Paddle Song at the school and some of the mothers really cried when they heard their kids singing in our Squamish language.

"That was the start of my cultural program. At first I worked with children at risk, those with low school attendance, behaviour problems and difficulty with schoolwork. They were tough kids. They had few boundaries and really low self-esteem. I needed to help them find something good about themselves. Now we have a mix that includes kids that have a pretty good chance of success at high school. There aren't so many kids at risk anymore because most of them have been through our program. We still have some kids that get to school really late and sadly most of them are still on welfare. A lot of our kids can't read or write, which makes school a really hard place for them. One of our boys, who has been here about two years now, could not write at all when he first came here, but we do some reading and writing in our program because we use journals and he wanted to do his journal like everyone else. Now we see a big difference in him: he can write a little bit on his own now and he feels more confident. Most of them do continue on through high school. Before *Chan Es7a7awts*, they were more likely to disappear from school by grade eight.

"We talk every day about how important it is to balance their education with their language and their culture. I tell them they have the pen in one hand and the eagle feather in the other and they are going to be strong and they can do anything. I tell them everyday how much we love them and how proud we are of them. We make them give themselves that pat on the back. At first it is really hard for them to give themselves recognition and praise. Now they can. We have watched them learn to love and respect themselves and that means they are able to respect other people.

"Part of our program focuses on trying to put them in touch with their spiritual side. We do this by working on it at the beginning of the three months that they are there. We start doing our breathing exercises, which are really important. The breathing exercises will give them

their vision of their guardian spirit, but it doesn't come easy. It's so beautiful once they do get their guardian spirit; they are so excited and proud. Their spirit may be a wolf, an eagle, salmon, bear, butterfly, hummingbird or maybe a geometric design. Lightning bolts come out a lot for the boys. Lightning is cleansing for Mother Earth and us.

"We celebrate with our music and dancing, and because we want them to know it is special, we ask them to make their own dance regalia. Regalia is very personal and reflects in many ways who we are so we tell them they have to have a vision of their own design. It is not an easy thing for them to do. We help them with the practical parts of making their regalia, but the design has to be their own special one. Often they will include their guardian spirit but other symbols or geometric shapes will be used to complete the design.

"We have a big celebration at the end of each session. Last time they were so excited in the changing rooms. They were all getting ready, putting on their regalia and it was just buzzing in there as they were talking away, not even listening to each other. We finally got them in line and then we had to wait, because the speaker ahead of us talked for a long time. It was really hard for them to stay quiet. A couple of the boys had said they didn't want to dance, but when we got there they both changed their minds and joined the rest as they roared out on the stage and danced up a storm. The other students who don't get to come to our program were 'yahooing' when they saw the kids dancing. I was so happy. They were so proud of themselves. We were proud of them."

Walking into Gloria's classroom you would never guess in a hundred years that some of these bright eyed, attentive students were problem kids. There is a sense of mutual respect and working together between students and staff. I participated in the talking circle, which begins each day and watched and listened while everyone spoke. They all had positive things to say about themselves and each other and they were genuine about what was said. The positive connection was tangible. I asked Gloria how this was achieved with such a mixed group.

"I don't know what it is, except that I respect them and love them. You can't fool kids; they must know that I am sincere in my feelings for them, our culture and our language. They know that I care about them. I thank them for going to school every day and I thank them for being in our program every day.

"You have to have a lot of patience and respect for them, speak the

truth and talk to them like they're human beings, because they are. I just share with them what our elders shared with me. I tell them about our roots, our family tree, our songs and dances. I try to teach them about love and respect, sharing and honesty. We talk about teachings for the drum and for dancing. I tell them how all of creation is sacred, the water, the air and the animals—that we are all part of creation and all of us are special. We work on ourselves, our physical, spiritual, mental and emotional wellbeing every day using our medicine wheel.

"Sometimes I wonder how can I just talk about all this for nine months, five days a week. It amazes me. I don't write anything down to prepare for what I'm going to say to them; it just comes to me. I believe it's our ancestors and the Creator talking through me."

I went to one of the celebrations. It was wonderful to see these kids just bursting with excitement and pride as they acted out the story of Raven Stealing the Light, singing "Go My Son" and, as Gloria would say, dancing up a storm. See for yourself in the photographs, their confidence and concentration as they celebrate or focus on their work in the classroom.

They have been given a gift for a lifetime. Gloria's hope and dream is that they listened and learned, through her, from the elders, and that they, too, will pass on to their children the teachings, the pride in their culture and of being a member of the Squamish Nation.

Perhaps here we are witnessing the beginning of that confidence and self respect we see in the powwow dancers. Who really teaches whom? The younger dancers bring in new ideas or moves that teach and surprise the older dancers; yet, originally the older dancers taught the young ones how to dance. That kind of circle exists not only in dance but also in all the paths of life. Where does it begin? Where does it end?

It begins and ends here with people like Gloria, an elder, who teaches kids to say and believe,

"*Chan Es7a7awts*," and with the kids who say loud and clear every day, "*Chan Es7a7awts*."

By inference they say, "If I can do it, so can you. Together we can do anything." The circle begins here. The circle ends here.

Chan Es7a7awts.

Appendix

Appendix 1: Powwow Etiquette

Honor and respect are the guidelines for powwow etiquette. The following guidelines are typical at all powwows and should ensure you do not inadvertently offend someone.

1. Alcohol and drugs are not allowed.

2. During the Grand Entry, Flag Songs and Invocation the audience is asked to respect the flags, veterans, dancers and speakers by standing. Men are asked to remove their hats; they may keep their hats on if they have an eagle feather attached to it.

3. Photography is not always allowed during Grand Entry. You must listen to the M.C. who will tell you if and when it is allowed.

4. Special ceremonies are shown respect by the spectators and dancers standing. The M.C. will give directions regarding standing and photography.

5. The front seats or the edge of the dance circle are reserved for dancers and their families. Most powwows have designated shaded areas for the elders to sit.

6. Parents are asked to respect the dance area and not allow children to run across it or onto it while there is a dance competition in progress.

7. Photographers are asked to stay off the actual dance area. Sometimes photographers will be seen inside the arbor, but these are usually official photographers.

8. Outside the dance arbor, please ask the dancers' permission to take their picture, whether it is video or a regular camera. Usually they will be pleased to let you do so. I have seen people butt into a group conversation to take a close-up without asking or even saying thank you!

9. Children are irresistible; however, please ask their parents if you can take their photo. Ask yourself if you would like a total stranger taking you or your child's photo without your permission.

10. Do not touch any regalia, including those wonderful bustles hanging on a post or chair. Common courtesy dictates that you ask permission. Remember the importance of the regalia. Some of it has been handed down through generations. Usually the dancer will be pleased to tell you about the regalia. This makes your photograph much more interesting because you will have some understanding of what it means.

11. Please do not touch the drums or any of the staffs you may see in the arbor or elsewhere. When all else fails and you are not sure what to do—ASK.

Powwow etiquette is fairly straightforward. Follow the guidelines and you will enjoy the event so much more because you will get to meet and talk to the dancers, drummers, officials and other spectators. You will also earn their respect. Meeting people is a major part of powwow. Gloria and I look forward to meeting you there someday.

Appendix 2: Tabulation of Dancers' Points

The benefits of being a full participant in the powwow become obvious with these two examples. The dancer who won both his contest dances, but did not take part in all the Grand Entries or both Exhibitions and Intertribals lost to the dancer who took part in everything and placed but did not win in his contest dances.

Dancer A

	1	2	3	4	
Grand Entries	100	75	50	25	**250**
Exhibition	20	20			**40**
Spot Checks	10	10	10		**30**
Contest	75	50			**125**
TOTAL					**445**

Dancer B

	1	2	3	4	
Grand Entries	0	0	50	25	**75**
Exhibition	0	20			**20**
Spot Checks	0	0	10		**10**
Contest	100	100			**200**
TOTAL					**305**

Appendix 3: Dance Contest, JUDGE'S SCORE SHEET

Total points available = 100

Keeping time with the beat of the drum	18
Start and stop with the drum	16
Full regalia	20
Regalia—overall effect, design, etc.	20
Fancy Dancers—variety and types of movements	16
TOTAL POINTS	**90**

MEN'S FANCY COMPETITION #_____

- All dancers must enter each 'round' to qualify for the finals.
- Dancers who lose any part of their regalia during a contest will be automatically disqualified.
- Dancers related to a judge are automatically disqualified, unless the judge withdraws.

Appendix 4: Drum Contest Judging Sheet
DRUM CONTEST

Session: Friday/Saturday/Sunday

Contest #_____

Number of Singers_____

Points 1–10 (high) Total

1. Cleanliness of drum area
2. Quality of song
3. Lead singer
4. Second lead singer
5. Appropriateness of song YES/NO (Deduct 10 points for No)
6. Ready to sing
7. Rhythm of the beat

MAXIMUM POINTS AVAILABLE = 70 TOTAL _____

JUDGE'S NAME: _____

DRUM ROLL CALL

Drum #	Present for Roll Call 4 roll calls max. pts = 15	Number of Singers lose 5 pts. per missing singer	Total
# 20	15, 15, 15, 15 = 60 points	12, 10, 12, 12 -10points @ second roll call	**50**
# 21	15, 15, 15, 15 = 60 points	10, 10, 10, 10	**60**

Appendix 5: Structure of the Songs

A song is made up of VERSES

Each verse is called a PUSH-UP

A push-up is made up of three parts:

1. LEAD is sung by one singer, a lead singer
2. SECOND is sung by all singers
3. THIRD first half and second half of the verse
 sung by all singers

The honor, or down beats, come at the end of the third part; this is when the dancers (Northern) raise their fans.

Diagram version:

```
┌─────────────────┐
│     LEAD        │
│ 1 person—lead   │
└─────────────────┘
        ┌─────────────────┐
        │    SECOND       │
        │  All Singers    │
        └─────────────────┘
                ┌──────────────────────┐
                │   PART 1 & 2         │
                │ REPEATED = PART 3    │
                │    All singers       │
                └──────────────────────┘
```

| PART 1 | PART 2 | PART 3 | The Honor beats come at the end and the dancer's fans are raised. |

All three of the above boxes = one verse or one push-up.

You will hear the M.C. ask for a number of push-ups from a drum when there is a tie and the judges need more time. A Whistle Carrier will usually expect four push-ups to be sung for his prayers to go to the Creator. Trick songs are structured the same way; they just stop and start in unexpected places.

Go get out a tape and listen. Did you raise your arm on the honour beats? Now you can hear the pattern and also know if it's a northern or southern drum group. Ray will be delighted.

Bibliography

Ancona, George. *Powwow*, New York: Harcourt Brace and Company, 1993.

Comstock, Tamara, ed. "New Dimensions in Dance Research, Anthropology and Dance—The American Indian," *CORD Research Annual VI*. New York: CORD, 1974.

Crummett, Michael. *Sun Dance*. Helena, Montana: Falcon Press, 1993

Heth, Charlotte, ed. *Native American Dance: Ceremonies and Social Traditions*. Washington D.C.: National Museum of the American Indian Smithsonian Institution, 1993

Hungry Wolf, Adolph. *Powwow: Dancers and Crafters Handbook*. Skookumchuk, British Columbia, Canada: Canadian Caboose Press, 1999.

Kurath, Gertrude P. *Dance and Song Rituals of the Six Nations Reserve, Ontario*. Ottawa: National Museum of Canada, Bulletin 220, 1968

Left Hand Bull, Jacqueline and Suzanne Haldane. *Lakota Hoop Dancer*. New York: Dutton Children's Books, a Division of Penguin Putnam Books for Young Readers, 1999.

Mansell, Maureen. *By the Power of their Dreams*. San Francisco, California: Chronicle Books, 1994.

Marra, Ben. *Powwow*. New York: Harry N. Abrams Incorporated, Times Mirror Company, 1996.

Parfit, Michael. *Powwow, A Gathering of the Tribes*. National Geographic Magazine, Vol.185, No.6, June 1994.

Paterek, Josephine. *Encyclopedia of American Indian Costume*. New York: W. W. Norton and Company, 1996.

Pringle, Heather. "Ceremonial Circuit." *Equinox Magazine*, July/August, 1987.

Power, Susan. *The Grass Dancer*. New York: G. P. Putnam and Sons, 1994.

Sherma, Josepha. *Indian Tribes of North America*. New York: Todtri Productions Limited, 1996.

Sherma, Josepha. "Through Indian Eyes. The Untold Story of Native American Peoples." Pleasantville, New York: *Readers Digest*, 1995.

Taylor, Colin, ed. consultant. *The Native Americans—The Indigenous People of North America*. New York: Smithmark, 1991.

Theisz, R. D. and Ben Black Bear, Sr. *Songs and Dances of the Lakota*. Rosebud, South Dakota: Sinta Gleska College, 1976.

More Great HANCOCK HOUSE Titles

Tlingit Art
*Maria Bolanz and
Gloria C. Williams*
ISBN 0-88839 528-0/ISBN 0-88839 509-4
8.5 x 11 • hc/sc • 216 pp.

Northwest Native Arts: Basic Forms
Robert E. Stanley Sr.
ISBN 0-88839 506-X
8.5 x 11 • sc • 64 pp.

Haida
Leslie Drew
ISBN 0-88839-132-3
5.5 x 8.5 • sc • 112 pp.

Northwest Native Arts: Creative Colors 1
Robert E. Stanley Sr.
ISBN 0-88839 532-9
8.5 x 11 • sc • 32 pp.

Northwest Native Arts: Creative Colors 2
Robert E. Stanley Sr.
ISBN 0-88839 533-7
8.5 x 11 • sc • 24 pp.

Tlingit: Their Art and Culture
David Hancock
ISBN 0-88839-530-2
5.5 x 8.5 • sc • 96 pp.

Potlatch People
Mildred Valley Thornton
ISBN 0-88839-491-8
5.5 x 8.5 • sc • 304 pp.

Buffalo People
Mildred Valley Thornton
ISBN 0-88839-479-9
5.5 x 8.5 • sc • 208 pp.

View all HANCOCK HOUSE titles at
www.hancockhouse.com